日本製カメラの変遷

THE EVOLUTION OF THE JAPANESE CAMERA

Philip L. Condax
Masahiro Tano
Takashi Hibi
William S. Fujimura

International Museum
of Photography at
George Eastman House

日本製カメラの変遷

**THE
EVOLUTION
OF THE
JAPANESE
CAMERA**

With the exhibition "The Evolution of the Japanese Camera," the International Museum of Photography at George Eastman House pays tribute to the phenomenal story of the growth of an industry. From a few companies producing copies of American or European cameras for a domestic market to many companies providing the world with the most sophisticated photographic and optical equipment, the history of the Japanese camera industry is a remarkable story, from the viewpoints of technology, manufacturing and marketing. We are proud to present it to the American public.

As there are many people who made the history of this industry possible, there are many individuals who enabled this Museum to organize this exhibition and make the history come alive.

Our appreciation must be expressed to all the member companies of the Japan Camera Industry Association, including its able Executive Director, Mr. Kanichiro Akiyama, and its current Chairman, Mr. Hideo Tashima, President of the Minolta Camera Company. JCIA is celebrating its 30th Anniversary this year, and this exhibition, in part, is a salute by George Eastman House to that organization.

We also want to express our deep appreciation to all of the staff of the Japan Camera and Optical Instruments Inspection and Testing Institute, which also is celebrating its 30th Anniversary in 1984. This exhibition is also partly a salute by George Eastman House to JCII and its unflagging standard of excellence. Most of the cameras in this exhibition were loaned to us by JCII from its own outstanding collection. Special mention should be made of Mr. Masahiro Tano, JCII Vice President, for the organizational efforts he extended in Japan on behalf of this exhibition. He is the author of a principal article in this catalogue. I want to thank also Messrs. Takashi Hibi of JCII and William Fujimura of Eastman Kodak Co. for their contribution to this catalogue outlining the history of optics manufacturing in Japan.

Our greatest tribute is to be given to Mr. Kinji Moriyama. Mr. Moriyama founded JCII thirty years ago and has devoted unbelievable energy, intelligence and commitment to this important institution as its President through those years. Beyond that, Mr. Moriyama has served for over thirty years in Japan's House of Representatives and, on occasion, in a Ministerial position in the government. He has wholeheartedly supported this Museum in its plans to present this exhibition and served as Chairman of the Japanese Committee for it. It is with the greatest respect that we consider this exceptional man as a friend of George Eastman House.

In closing, I want to thank JCII, each of the camera companies and the Japan Foundation for the support they have provided to make this exhibition happen.

Robert A. Mayer

LETTER FROM THE PRESIDENT
JAPAN CAMERA AND OPTICAL INSTRUMENTS
INSPECTION AND TESTING INSTITUTE

It is my great pleasure to see that the International Museum of Photography at George Eastman House has organized a very significant cultural exhibition, "The Evolution of the Japanese Camera," showing the origin of, and a step-by-step guide to, the development of the Japanese camera. Because of their high quality and reasonable price, Japanese cameras have been widely accepted and appreciated by many photographers throughout the world. They have thus played a very important role in various fields of modern culture through photography.

The aim of the exhibition is to display cameras that will show their progress made to date to the public in the United States. Exhibited here are about 420 models of historical Japanese cameras, including the Cherry Portable of 1903, which was the first Japanese camera resembling European and American advanced cameras; many improved types of cameras affected by optical ordnance technology, which was highly developed during the Second World War; then today's cameras incorporating the latest electronic technology.

Japanese camera manufacturers have, of course, produced many more cameras than we have here and supplied their products to customers all over the world. These exhibits are limited to those noted by Japanese experts for their special features.

Because it is the first time ever that these historical Japanese cameras are being shown systematically to the public in this way, we are confident that the exhibition will give people some idea of the new knowledge in this field.

About 340 of the 420 models in this exhibition are from the museum in the Japan Camera and Optical Instruments Inspection and Testing Institute (JCII). I understand that the Director of the International Museum of Photography got the idea for this exhibition when he came to Japan in 1981 and visited this museum. I, as the president of the JCII, am very proud to have the chance to show these cameras collected by our institute to the American public.

Many people from both the International Museum of Photography and Japan, including those from the Japan Foundation, camera manufacturers and others, all of whom it would be impossible to list here, have our heartfelt thanks for their cooperation in making this exhibition a reality. They have supported this exhibition financially and have contributed many of the cameras on view.

Japanese cameras were a leading export item to the U.S. during Japan's postwar rehabilitation and were very popular with the American public, who have been, and still are, great camera lovers. We Japanese are delighted to have the chance to present this so-called "cultural mission" to the U.S. and hope, in closing, that it will be like a "mustard seed" to the American public, leading to a deeper understanding of Japan.

Kinji Moriyama
Member, Japanese House of Representatives

THE EVOLUTION OF THE JAPANESE CAMERA

日本製カメラの変遷

**THE
EVOLUTION
OF THE
JAPANESE
CAMERA**

The roots of the Japanese camera industry can be traced to late Victorian times. The earliest cameras were the work of Japanese craftsmen, who transferred their reknowned cabinetmaking skills to the production of a very limited number of wooden view cameras. The designs were traditional and nearly identical to cameras being produced throughout the world. One model, called the Paulonia, won the second prize silver medal at the Paris Exposition of 1900, a tribute to a very high standard of workmanship. The cabinetmaking art was readily adapted to the production of wooden cameras, so the sequence of events in Japan was essentially the same that had taken place earlier in Europe and the United States. There was no optical industry in the country. Lenses and shutters were imported.

The first camera made for reasonably large scale distribution was the Cherry, manufactured in 1903, in a simple little box type for use with glass plates. Paperbacked rollfilms were not made in Japan at that time. The very small plate and film industry that did exist was limited to the production of plates and sheet film. Rollfilms had to be imported at great expense and generally arrived in poor condition. Refrigerated cargo ships and tropical packing were in the future. The Cherry was made by the predecessor firm of Konishiroku, now the second largest manufacturer of photographic supplies in Japan. Cameras made during this period were intended for a small domestic market. There was no significant effort to export. Although the industry expanded substantially in the years prior to the Second World War and quality improved, it still remained well below that of the industrialized nations of the West. Designs were invariably copies of successful American and European products and only occasionally was there any effort at originality.

In the years immediately following the war, the industry had to face a severe raw materials shortage, which obviously complicated the process of rebuilding. With the need to direct all their efforts at the essentials of survival, little time could be given to developing new models, so the first products were carryovers from pre-war designs. The shortage of materials and capital needed to finance new plant and equipment slowed efforts to rebuild. Despite the obstacles, production was getting started and a labor force assembled with the skills needed to make high-grade products. The Nikon I, based on a pre-war German design, was exceptionally well-made and focused attention on the Japanese camera industry.

A version of this camera proved its worth in combat in Korea, and many of them found their way to the United States via American military personnel.

As the market started to expand, industry leaders recognized that growth could continue only if the manufacturers established and adhered to a rigid set of quality standards. The Japan Camera and Optical Instruments Inspection and Testing Institute (JCII) was established in 1954 under the leadership of Mr. Kinji Moriyama. This year, 1984, marks its 30th anniversary with Mr. Moriyama as director. Before a camera qualifies for export, it must pass a rigid series of quality tests. Regular random sampling and testing of production is an ongoing procedure that insures the maintenance of high standards. The only exceptions to this rule are very simple cameras fitted with single element lenses. JCII is funded by fees assessed for the inspection and testing of products that are to be licensed for export, and functions as a completely independent agency. The vigor with which the industry self-policed its growth through JCII is almost unique in the industrialized world for a consumer product. In less than a decade, the term "Made in Japan" had come to signify a product of superior quality.

With little export experience in the early years, the companies worked closely with American importers that had the marketing skills needed to sell their products. The combined efforts of JCII, working with the manufacturers in Japan and a number of American importers, gave birth to the modern Japanese camera industry. Of the traditional manufacturers of photographic equipment, namely the United States, Germany, France and Great Britain, it was Germany that was to feel the effects of Japanese competition most acutely. American, British, and French manufacturers had, to a large extent, abdicated the premium camera market because of vigorous German competition, and twenty years ago the Japanese firms regarded the German manufacturers as their chief competition. Today, the significant competition is internal. The staggering variety and volume of products produced during the past two decades has made Japan the preeminent manufacturer of high-grade photographic equipment. The products and graphics in this exhibit tell a remarkable story.

The introduction of the Nikon F in 1954 was one of the watersheds in the history of camera design during the last thirty years. The Nikon F became the most successful single-lens reflex camera ever marketed and paved the way for many of similar design that were to follow. This camera is an excellent example of the unique synthesis of innovative and adaptive skills that has propelled the Japanese camera industry to its position of leadership today. The modern Japanese camera combines new ideas with recognized

sound design features that have been greatly improved, and it is sold at a highly competitive price.

Automation in camera design has been carried to heights of sophistication only speculated about a decade ago. Eastman Kodak and the Polaroid Corporation in the United States have been striving for years to free the picture taker from a series of decision-making activities. The efforts of these firms have been directed at the amateur interested in simple snapshots. The Japanese companies have succeeded in another area. With skillful designs, they have managed to overcome many of the prejudices held by serious amateurs and professionals concerning automated photography. It was not a simple task. Many photographers felt that each automated function was a potential creative variable which would be denied them. To overcome this problem, the designers took full advantage of miniaturized electronics to create automatic exposure systems that allow the professional to retain control of the image-making process. Ideas were tried because they were possible; they were retained because they were desirable. The Japanese camera today is a marvel of technological sophistication.

Philip L. Condax
Director, IMP/GEH Technology Collections

日本製カメラの変遷

THE
EVOLUTION
OF THE
JAPANESE
CAMERA

A BRIEF HISTORY OF JAPANESE CAMERAS

The camera empire today started from copying

The birth of the camera, as it is known today, was really about 1880, when dry plates first went into common use as photosensitive materials. In the years before this, when daguerreotypes, calotypes or wet plates were used, the biggest concern was for the preparation of sensitized materials. Photographers actually made these themselves whenever they were going to take pictures and the cameras used then were simple "dark boxes with lenses," a far cry indeed from today's cameras. They were very basic, wooden structures and traditional woodworking craftsmen in Japan were easily able to produce imitations of the imported version.

Meiji Era (1868-1912)

Dry plates revolutionized camera technology, and with these came the birth of today's camera structure. This revolution, however, was taking place in developed countries, i.e., Europe and the United States, and thus even imitations could not be produced in Japan at this time, owing to its limited industrial and technical development.

But gradually, private concerns such as Konishi and Asamuma, which had expanded from pharmaceutical firms into photographic material suppliers, started selling studio and field cameras made by their woodworking shops as an extension of their main line of business, importing photographic materials and lenses for professional photographers.

Very few people had cameras. Apart from professional photographers, only a small segment of society, i.e., nobility and the wealthy, had access to them. From about 1900, however, the general public, or more specifically many amateur photographers, managed to obtain them.

It was about this time also that many kinds of excellent English and German lenses and high-grade cameras for dry plates, as well as American Kodak cameras for rollfilms, appeared in Japan, although the influence of all these was very small scale.

Birth of the portable Japanese camera

It was under these circumstances that the first portable Japanese camera, the Cherry Portable (a box model drop-plate magazine type for twelve 2¼ x 3¼ inch dry plates, made by Konishi-Honten) went on sale in 1903. By the end of the Meiji era (1912), various other cameras, also made by Konishi-Honten, had hit the market. Among these were the Sakura Pocket Prano (a bellows-type camera for 3¼ x 4¼ inch dry plates), the Sakura Flex Prano (a single-lens reflex camera with a focal plane shutter speed of 1/1000 sec.), the Sakura Stereo Prano (a bellows-type stereo camera), the Pearl Portable (a bellows-type which could take either 118 size rollfilm or 3¼ x 4¼ inch dry plates), the telephotographic Idea (a 3¼ x 4¼ inch box model with a telephoto lens) and the Minimum Idea (a 2¼ x 3¼ inch folding model).

Pocket watch-type subminiature cameras named Radio Cameras were made and sold by the Ueda camera shop in Osaka. They also sold many other types of cameras under the name "Star."

Taisho Era (1912-1926)

Continuing on from the Meiji era, the Lily Portable (a 2½ x 3½ inch horizontal hand camera) and the Pearl II (a rail type folding camera for 120 size rollfilm), both made by Konishiroku-Honten, were sold equipped with imported lenses and shutters.

Two other cameras made by Sone-Shunsuido in Kanda, Tokyo, were also on the market. The Sweet, a camera that used zero-size dry plates, which were only a quarter of the 3¼ x 4¼ inch ones, was aimed at the general public.

In June 1925, the end of the Taisho era, the Pearlette made its debut. This metal, bellows-type camera took 127 size rollfilm. It was, in fact, the result of a successful attempt to copy Eastman Kodak Co.'s Vest Pocket Kodak and Contessa Werk's Piccolette, and it was thus fitted with an imported lens and shutter. Over the next twenty years, Konishiroku improved their Pearlette time and time again, and not surprisingly, it became a symbol of "all-Japanese excellence."

Pre-War Showa Era (1926-1945)

For the camera industry, the twenty years of the Showa era before the Second World War ended were years of storm and stress. After the financial panic in 1927 came an acute business slump, followed in 1929 by the crash of the New York stock market. The 1931 Manchurian Incident saw the country preparing for battle, and in December 1941, Japan committed itself to the Pacific War.

Emergence of Camera Manufacturers

Although these were lean years for Japan's camera industry, they were years of development. Konishiroku-Honten gradually stopped importing goods and concentrated, instead, on turning out its very advanced cameras. The "all-Japanese" Pearlette, the Semi Pearl, the Baby Pearl, and the 2½ x 3½ inch Lily all hit the market in rapid succession. In 1937, when the company became a munitions company and began producing aerial cameras and X-ray photographic equipment, it changed its name to Konishiroku Co., Ltd.

From the time of its establishment in 1917, Nippon Kogaku K. K. was a munitions optical instrument shop, but in 1932, it produced its first photographic lens, the "Nikkor." This was fitted to the Hansa Canon and put on the market by Seiki Optical Research Institute (now Canon) in 1936.

Asahi Optics began producing lenses about 1931. Its single-element and Optar f/6.3 lenses for the Pearlette were followed by its Promar lens for the Minolta reflex camera in 1941.

Minolta produced a folding hand camera in 1931. With the help of German employees, the

company then went on to produce the Minolta Vest, the Minolta Six, the Auto Press Minolta, the Minolta Flex, and a variety of other models.

Olympus successfully produced its Zuido photographic lens about 1936. This was fitted onto and sold with its Semi Olympus, Olympus Six and other cameras.

Tokyo Optics, another military optical instrument shop competing with Nippon Kogaku K. K., marketed the Minion, which could take ten frames on 127 size rollfilm equipped with the Licht shutter made by Seikosha. The Kuribayashi Camera Factory (now Petri) produced various cameras for dry plates and rollfilms under the brand name "First." Riken Optics (now Ricoh) was another company that started off as a manufacturer of sensitized paper for photocopying, although it also turned its interest towards making and selling various cameras aimed at the general public in 1938. In 1940, just before the war broke out, Mamiya successfully produced the Mamiya Six, a unique back-focusing type with a coupled range finder. Elmo was a company that specialized mainly in the projectors of 16mm movie films, but in 1938 it started selling the Elmo Reflex, a twin-lens reflex camera. Fuji Photographic Film Co. was established in 1934.

Although a diversity of cameras made in Japan was thus available, German makes such as the Leitz, Zeiss Ikon and Rollei accounted for most of the "quality" products on the market. But these German cameras were naturally very expensive, and because most people could not afford them, they bought Japanese imitations instead.

Just as the Japanese camera industry started showing definite signs of growth, this growth was stunted. The ban enforced on July 7, 1940, limited production to cameras for military purposes only, and as a result of air attacks, factories were burnt down . . . literally reduced to ashes

Post-War Comeback (1945-1954)

Despite the marked social despondency and scarcity of commodities in Japan just after the war, production of cameras was resumed surprisingly quickly. The reason for this was that the General Headquarters of the Occupation Forces ordered that cameras be supplied by Japan for sale to military personnel, for private use. This earned hard currency which could be used to help purchase imported food, essential to rescue Japan from starvation.

In 1950, more than 100,000 pieces of 35 mm, folding, twin-lens reflex and other cameras were produced. These were all marked "Made in Occupied Japan." Theoretically, these could officially be sold domestically, but with a 120% tax levied on them, they were simply beyond the means of most Japanese at the time. Consequently, many different types of cheap mini-cameras (these took 14mm width rollfilm with backing paper) were made and sold.

Although the cameras produced in this period were basically the same as previous pre-war models, wartime optical precision instrument technology had a very strong influence on the camera industry and cameras that were much more advanced than those produced before the war began appearing. Among these were the Nikon M, the Canon IV Sb, and other models.

In 1950, during the Korean War, photos taken of the war with a Nikkor lens by a *Life* magazine cameraman, Mr. David D. Duncan, were very well received. The boost this unexpected praise gave the Japanese camera industry is almost unbelievable.

Economic expansion resulting from the Korean War stimulated domestic demand for cameras and brought about an unprecedented boom. Countless small and large companies were pitted against each other and there were about 80 types of twin-lens reflex cameras being produced.

With the end of the Korean War in 1953 came a sudden depression. As a result of this, small manufacturers with weak management structures became insolvent one after another, and thus only companies that could withstand the excessive competition advanced as leading manufacturers.

But even these leading manufacturers had to take stringent measures to rationalize production, and it could be said that they were forced to explore sales routes overseas. They realized the importance of cooperation and established JCIA (Japan Camera Industry Association) and JCII (Japan Camera Inspection Institute) in 1954.

Period of Growth

The decade from 1954 to 1964 was a period of growth for Japan's camera industry. In the years before, it had simply followed in the footsteps of the German industry, making similar products primarily for the domestic market.

But this was no longer the case, and during these years, the "Made in Japan" label had to compete actively against German products on overseas markets. Although the industry as a whole was of course doing research on various topics and looking ahead, the emphasis was now on developing and supplying more distinctive cameras.

Age of Electronics (1965-1983)

Vigorous research efforts directed towards more precise assembly of the camera were investigated. Determination of accurate exposure by integrating the iris and shutter diaphragm mechanically with an exposure meter was necessary.

The one electronic part was the electric exposure meter. The selenium photo cell, which could not withstand much vibrational impact, was replaced by a cadmium sulphide cell powered by a mercury battery. Although the electric current obtained as a result was tens of thousands times stronger, it was not always used effectively by the meter.

In 1963, the first camera featuring automatic electronic exposure control, the Polaroid Automatic 100, reached the market. Prontor and

THE EVOLUTION OF THE JAPANESE CAMERA

Compur of Germany were next, with the announcement of their electronic shutters at about the same time. But Japanese cameras had a definite edge; backed up by an up-to-the-minute electronics industry, these cameras were characterized by ingenious electronic innovations.

In 1965, the first Japanese cameras having electronic shutters appeared. Among these were the Yashica Electro Half and the Olympus 35 EM (both fitted with the Copal Elec shutter), and the Olympus 35 LE (fitted with Seiko ES shutter). In 1968, the first camera incorporating ICs, the Yashica Lynx 5000 E, appeared. The Asahi Pentax ES (Electronic Shutter), the first single-lens reflex camera with an electronic focal-plane shutter, was put out in 1971. What set the ES apart was the incorporation of a memory circuit into the single-lens reflex through-the-lens photometer, as this had been considered a difficult step. For its OM-2, which appeared in 1975, Olympus devised a method by which the light striking the surface of a film during exposure could be measured. This camera did not have a memory circuit but its automatic flash exposure was an important feature. The application of electronics was not limited to 35 mm cameras: 6 x 6, 6 x 7 and 6 x 4.5 medium-format cameras (such as the Mamiya and Bronica) also featured such changes.

Electronic Flash

The electronic flash for illumination is just another example of the changes made through the application of electronics during these years. Although the first electronic flash, the Kodatron, appeared in 1940, things really started moving in 1957, when transistors were used in the Mecabliltz 100. The high-voltage power sources thus devised replaced the former heavyweight units, and from this point progress was very rapid. Electronic flashes then replaced the conventional expendable flash lamp. The further development of the electronic flash enabled not only the incorporation of self-controlled flash units into cameras, but also the automatic control of the electronic flash and the electronic shutter.

Birth of the Electronic Camera

The Canon AE-1 went on sale in 1977. This camera represented a jump from the camera with an electronic shutter to the real electronic camera. Thanks to CPU (Central Processing Unit) based sequential control and a digital memory, the electromagnetic release, self-timer and electronic flash could be linked up electronically. Another feature of the camera was that the number of parts used was down sharply (with about 300). Canon then further developed this system and the result was the Canon A-1, the camera that controlled everything electronically. It came out in 1978.

Meanwhile, other manufacturers were not idle. Cameras such as the Olympus OM-2, the Nikon FE, the Minolta XD, the Asahi Pentax ME, the Contax 139 Quartz, the Mamiya ZE-X and other electronic cameras featuring the incorporation of various original methods, were all developed very quickly also.

Cameras became more and more electronically sophisticated. Even focus adjustment became electronic. At the 1963 Photokina, the Canon AF received a lot of attention when it was publicized as a test-model automatic-focus camera. In 1971, Nikon announced the development of its automatic focus, interchageable lens at the Chicago Camera Show.

In 1977, Konishiroku took the plunge and marketed the Konica 35AF, which had parts patented and supplied by Honeywell of the United States. The Canon AF35M, a unique automatic-focus camera using infrared rays, came out in 1979. This camera had many features: automatic exposure and focusing, an electronic flash, and an automatic function for the winding and rewinding of film.

Cameras even started "talking." The Fuji Instant Camera F-55 Voice was aimed at the domestic market and went on sale in 1982 as the "Fotorama" instant-photo system. This camera featured a new method of electronically transmitting instructions such as "Please load the film," "Please use the flash" etc. in the form of a synthesized voice.

Advancements Not Limited to Electronics

The advancement of the Japanese camera was due not only to electronics. Camera materials, lenses and mechanical shutter elements are very different from those used 20 years ago, and with the automatic assembly of cameras by robots, their structures and functions have been completely changed.

Although plastic materials, for example, once stood for cheapness, they are now used in all medium-priced leaf-shutter cameras and for such high-quality single-lens reflex cameras as the Canon T50. This remarkable change is attributed to the astonishing progress that has been made with plastics. Titanium is highly valued as a strong metal, and it is, therefore, used for body covers and shutter curtains, too.

On the other hand, gold is often used on the electrical contact points of various parts. Many years ago, some rather foolish people would have been delighted to have a gold-plated camera. Most people nowadays would probably be amazed if they saw that the insides of recent cameras are a brilliant golden color. The underwater camera is a noteworthy example of a comprehensive combination of materials.

With the presentation of Duffieux's theory of Optical Transfer Function in 1946, the application of OTF to both the design and the evaluation of lenses drew considerable attention. The practical application of OTF theory to the design and evaluation of Japanese camera lenses was very quick

and appropriate, and as a result of this, the image formation performance of these was improved remarkably.

Progress made with computers also had a very profound effect on the design of various lenses. It is highly likely that, without computers, the development of the more than 1000 types of high-performance zoom lenses having a wide range of focal lengths would just not have been possible.

Multi-layer coating technology for lenses, the aspherical lens and the introduction of various new types of optical glass for lenses all significantly contributed to the control of veiling glare and the spectral transmittance of camera lenses. Such features are essential if vivid color photos are to be obtained.

Technology related to unintentional camera shake due to the shutter movement accelerated the improvement of camera shutters. One example of this is the Nikon FE 2's 1/4000 sec. shutter speed.

A high degree of proficiency is required in the production of such high-performance lenses and cameras both in the manufacture of parts and in the assembly of completed products, but in Japan, robots, rather than automatic machinery, are now employed. As was mentioned above, new technological developments in various fields were thus applied to, and combined in, cameras, giving rise to unique camera technology.

Thanks to such developments, high-performance, high-reliability cameras could be supplied to customers at lower prices all over the world, the number of people buying cameras increased and photographs were more widely used. The cultural significance of these changes is, therefore, not to be underestimated.

FEATURES OF THE JAPANESE CAMERA INDUSTRY

Evolution Rather Than Innovation

The development of the Japanese camera was not a result of any special innovations. Its present success is due rather to the progressive accumulation of precision technology. This progress should, therefore, be considered a kind of "evolution" rather than "innovation." The most important items as far as the development of the camera over the last 30 years is concerned, e.g., the automatic control of exposure, the zoom lens, electronic flash equipment, in-camera processes, the electronic shutter, and auto-focusing, were all the work of foreign inventors.

Japan's success story, however, is another matter. Through the application of advanced, industrialized technology and Japanese-style management, Japan quite openly manufactured its own products, which were improved time and time again, and was thus able to supply its customers with quality products that were easy on the pocket.

After 1960, such improvements and developments occurred very quickly, and between various manufacturers, the competition was absolutely cut throat (Please refer to the section on 1954-1964 of the last chapter). This competition did not come from a Germany or America, but sprang up between Japanese manufacturers competing at the domestic market level. It did, however, reach overseas markets; some overseas manufacturers just could not compete with the quality and prices and went out of the running altogether as a result.

According to JCII records, 170 companies have made cameras since 1954, the year of establishment of the organization. There are now only 32 manufacturers, which means that the majority simply dropped out somewhere along the way. The competition over this 30-year period was obviously particularly intense—only 11 of the above 32 companies were in business in 1954. Such companies are well versed in the rules of survival, thanks to their many years of experience based on their own philosophies. In other words, the secret is not to take risks with innovations, but to constantly improve and develop. This is the key to a strong industry, they believe.

A Nation of Camera Lovers

The Japanese are famous camera lovers, and overseas it is often sarcastically said that if a person wears glasses and has a camera around his neck, he's Japanese. More information on this is given in the preface of "The History of the Japanese Camera" by Mr. Kinji Moriyama, published by the *Mainichi Shinbun* in 1975. To cut a long story short, however, the support of the Japanese public as a nation of camera lovers, was, and still is, a major reason behind the development of cameras here. Japanese manufacturers maintain their market shares by designing cameras that people will be delighted to buy.

Higher Technical Level in Factories

It is certainly true that factory workers in the camera and other industries are highly intelligent and skilled. According to government statistics 99.98% of Japanese have fulfilled the requirements of compulsory education, 94% go on to three years of high school and 35% of them to college or university.

This, therefore, means that almost all factory workers have graduated from high school and that many are university graduates. Because they are promoted according to their ability, they study subjects they are particularly interested in, in addition to their on-job company training. There is little distinction between so-called white- and blue-collar workers, as is demonstrated by the fact that the difference in the salaries of executive and other employees is minimal. The importance of a family-like employer-employee relationship is stressed, so much so that the fate of the company is the fate of the worker. Success has been, and is being, achieved by this social structure, exemplified by Japanese-style management and the advancement of intra-company Total Quality Control.

Because manufacturers employ many university graduates, the link between companies and universities is a strong one. The August 1984

THE EVOLUTION OF THE JAPANESE CAMERA

general meeting of the International Commission for Optics, which is to be held in Sapporo, will be attended by several hundred optical institute authorities from all over the world. Many researchers from Japanese camera companies are also expected to participate in this academic debate.

Reliability and Quality Assurance

Japan produced 16 million cameras in 1983, about 65,000 daily. With so many new cameras being used all over the world, the problem of mechanical failure is a very serious one. After the Japan Camera Information and Service Center opened in New York City in 1955 headed by Mr. K. Moriyama, it received complaint after complaint from dissatisfied customers for quite some time. This experience prompted the industry to patiently seek methods of making Japanese cameras more reliable. A book could be written about the role JCII played in this process.

The concept of reliability was a new technology first researched in the USA by the Airforce Development Center and the RETMA (now the EIA—Electronics Industries Association) about 1960. In 1963, JCII established a society of research reliability with 10 major camera manufacturers. This research on camera reliability is still being done today. Although the results of this research may be applied to inspection standards when appropriate, they are usually taken advantage of by the camera industry. These companies have progressed from the factory QC stage in its initial processes to the present TQC system. Theories on reliability are put to practical use and thus the age of QA (quality assurance) is now dawning.

Transfer of Technology Between Industries

As a result of Japan's demilitarization 39 years ago, the camera industry literally bloomed under the influence of optical weapon technology. Japan's camera industry is now invading the "image-information technology" industry. Since 1975, less than 50% of the total of the sales volumes of 11 major camera companies has been from sales related to the photographic business.

It appears likely that even more progress will be made in the future with electronic devices and apparatus, including office automation and opt-electronic products other than cameras. As long as human sight is the information organ enabling a maximum information density to input, then even with electronic recording media and display methods being applied, the camera will provide unlimited possibilities as an image capturer. Japan's camera industry is actively absorbing electronic industry technology, but changes in Japan's camera technology have, in turn, already affected this field in the same way.

FUTURE OF THE JAPANESE CAMERA

In the previous section were explained the various factors which have enabled the Japanese camera to adjust successfully, along with progress made

with the silver-halide photographic system and the circumstances surrounding this adjustment—all of which led to the formation of today's "camera empire." It is certain that the silver-halide photographic system, which is more than 100 years old, will be developed even more in the future, and that the development of cameras will also advance as new technology in other fields is taken advantage of.

On August 24, 1981, Sony of Japan announced that it had created a new type of photographic system, the Mavica. The Mavica does not have any silver-halide sensitized materials. Charge Coupled Device on the image-formation surface of the camera enables the light that strikes the CCD by shutter action to be stored on each CCD element as an electrical charge. While this electrical charge is scanned, as with a VCR camera, it is digitally recorded on a tiny magnetic disk. Although this recording can be looked at on a CRT, like with a television set, or printed out as a hard copy by a printer, an outstanding feature is that it can be directly transmitted over long distances.

Many people have already compared this type of system with silver-halide photography. Because the image quality, cost and convenience of these are all factors that vary depending on use, however, it cannot really be said that one system is better than the other. It is by no means thought that electronic recording systems will replace silver-halide photographic ones. On the contrary, both types of system will probably thrive in the respective fields in which they are used. The development of both will, therefore, continue, side by side, for some time.

But with electronic recording systems being backed up by the very rapid development in various electronic industries, the development of this course will be faster—the silver-halide recording system, has, after all reached its peak.

In addition, because this new system technology is still being developed, it possesses many uncertainties. It would take many years to have it distributed worldwide, because the technological possibilities of a system are not always a good indication of its commercial success. It is also true that they are different in recording systems, but cameras, image capturers, have their same basic structures, i.e., their objective lenses, diaphragms and shutters, finders and light-tight bodies.

Incidentally, electronic recording systems are being standardized in Japan and foreign companies are included on the committee, so it is thus expected that these will be put out as actual products in the near future. The role of Japan's camera manufacturers in this progress is sure to be even more important than it has been to date.

Masahiro Tano
Vice President
Japan Camera and Optical Instruments
Inspection and Testing Institute

HISTORY OF JAPANESE CAMERA OPTICS

This chapter was written to augment the camera listing and description chapters of this catalogue so the reader will have a better understanding of the historic background of how, who, and when the Japanese lens manufacturers evolved and interfaced with the camera manufacturers. Many articles on this subject have been published in Japanese, but to our knowledge, none written in English. It is our hope that this short summary will give the photographica enthusiast, as well as photohistorians, a place to start if they wish to research Japanese photo-optical history.

Pioneers in Japanese Lens Making

Camera bodies were manufactured by the Japanese as early as 1868, but production of photographic objectives did not occur until much later. It is recorded that the optical industry was started in 1873 by a Matsugoro Asakura, who was sent to Austria by the Japanese government to learn optical fabrication. He returned to Japan in 1875 and, with government approval, started to build an optical fabrication plant, but unfortunately passed away prior to its completion. However, some of his students acquired sufficient knowledge of the art from their master to continue his project and by the fall of 1876, started to produce ophthalmic lenses. The material (glass) during this period was imported from abroad, because glass melting technology had not yet been developed in Japan.

By 1883, Matsugoro's son, Kametaro Asakura, started to develop a photographic lens at his Yotsuya Denmacho ophthalmic manufacturing plant in Tokyo and was able to exhibit his new creation at the third national industrial exhibition (1890) where he was awarded first prize, making this the first recorded photographic objective (with exception of simple single-element lenses) produced in Japan.

The next important name that appears in the development of the photo-optical industry of Japan is the Fujii brothers. The older brother, Ryuzo, became a naval engineer after graduating from Tokyo Institute of Technology with a degree in Mechanical Engineering. His assignment was to study science in Europe for a period of three years. He spent most of the time in Germany, studied optics from optical design to lens fabrication, and returned to Japan in 1901. In 1908 he left the service to start his own company, calling it Fujii Lens Seizosho (Factory).

His brother Kohzo, who had graduated from Tokyo Imperial University with a degree in applied chemistry, had joined the Aichi Cement Company and had worked his way up to a director and plant manager of the company. When his brother started the Fujii Lens Seizosho, he too left his company and joined his brother in the new venture.

They rented a dirt floor foyer of a residential home and started to research methods of producing prisms and lenses. The following March they moved to a new factory in Shiba district of Tokyo and equipped their plant with the then newest optics fabrication equipment from Germany and optical measuring instruments from Carl Zeiss Jena, making their facility the first modern optical plant in Japan.

Commercial glass (such as window glass and bottles) melting technology was imported in 1887, but optical glass melting was not attempted until 1915 when the Department of Navy started the development of optical glass manufacturing due to the stoppage of importation of Jena glass from Germany because of World War I.

Completely independent from the Navy, research of optical glass melting was started at the Osaka Industrial Material Testing Laboratory belonging to the Department of Agriculture and Commerce in 1921. Prior to this time optical glass was imported from Germany, France and England.

Well-known photographic and optical companies

To give photohistorians and readers of this catalogue a quick outline of the companies in Japan that engaged in the design and manufacture of optics, a brief summary of the company history of the better-known photo-optical companies are listed in alphabetical order.

日本製カメラの変遷

Asahi Optical Company, Limited
(Asahi Kogaku Kogyo K.K.)

This company started in 1919 as the Asahi Kogaku Goshi Kaisha in the Toshima district in Tokyo, manufacturing ophthalmic lenses by Kumao Kajiwara. In 1923, it marketed its first motion-picture projection lens named the "AOCO" projection lens. In 1929, it launched into the design and manufacture of photographic objectives and by 1934 became a major supplier of lenses for other camera manufacturers.

For Minolta it produced the 105mm f/4.5 triplet "Corona Anastigmat" in 1931, the 105mm f/4.5 triplet "Actiplan Anastigmat" in 1933, a 75mm version of the "Corona Anastigmat" in 1935, 75mm and 105mm f/3.5 "Tessar" type 4 element lens named "Promar Anastigmat" in 1937.

Camera Name	Lens Name	f/No.-EFL	Year
Eaton	Corona Anast.	4.5 105mm	1931
Happy	Corona Anast.	4.5 105mm	1931
Minolta	Actiplan Anast.	4.5 105mm	1933
Semi Minolta	Corona Anast.	4.5 75mm	1935
Auto Semi Minolta	Promar Anast.	3.5 75mm	1937
Auto Press Minolta	Promar Anast.	3.5 105mm	1937

For Konishiroku it produced the f/8.0 Achromatic Doublet, 75mm and 105mm f/6.3 and f/4.5 triplet "Optor Anastigmat".

Camera Name	Lens Name	f/No.-EFL	Year
Pearlette	Achromat	8.0	1932
Pearlette	Optor	6.3 75mm	1932
Idea Mod. 8	Optor	4.5 105mm	1933
Pearl Mod. 8	Optor	4.5 105mm	1933

In 1945 during the war, most of the factory was destroyed by bombs and for a short period at the end of the war, the company was forced to dissolve. In 1948, it started over as the Asahi Optical Company (Asahi Kogaku Kogyo K.K., the present name) and manufactured binoculars for export. In May 1952, Asahi introduced its first camera which was said to have been designed as a camera for the celestial telescope it was marketing. It was a 35mm single-lens reflex with a waist-level focusing finder. The name "Takumar" appeared on Asahi lenses for the first time. It was a 50mm f/3.5, 4 element in 3 group design based on the German Carl Zeiss "Tessar" lens. Since then, Asahi stuck to the trade name Takumar for all its lenses (as in Super Takumar, Auto Takumar, SMC Takumar, etc.) until 1976 when it renamed its lenses "SMC Pentax" for its new "K" and "M" series 35mm SLR camera which required a new bayonet mount. This was done to avoid confusion with the threaded mount used on the earlier Takumar lenses. SMC comes from Super Multi Coated and is a 7 layer multi-coated anti-reflection coating on the glass surface to reduce reflection, flare, ghost, and increase contrast and optical transmission. It was first marketed in the U.S. on November 20, 1970, but was introduced at the 1970 Photokina with the announcement of the Pentax 6x7 camera. The know-how was said to have been purchased from OCLI in California and developed for mass production.

Canon Incorporated (Kabushiki Kaisha)

This company was started in November 1933 as the Seiki Kogaku Kenku Sho by Dr. Mitarai, an obstetrician (by profession) and an avid amateur photographer. By 1935 it built its first prototype camera and called it the "Kwanon" camera. This 35mm Rangefinder camera featured cloth focal-plane shutter with speeds from 1/20-1/500 second, a 50mm f/3.5 "KasyaPa" lens, a body that resembled the Leica II but with corners squared off like the subsequent production Canons, and with the viewfinder between the rangefinder windows *(a la* Leica II). The first production camera renamed "Hansa Canon" was also introduced in 1935. The lens for this camera was not a Canon make but a Nikkor f/3.5 5cm provided by Nippon Kogaku (mentioned below). It was not until 1939 that Canon, then called Seiki Kogaku Kogyo K.K. (renamed August 1937), started producing its own lenses. The first lens was the 5cm f/1.5 Seiki Serenar lens used on the Seiki X-ray camera prior to the end of the war. The first 5cm f/3.5 Serenar used on a consumer product 35mm camera appeared on the post-war Canon J camera. When the company name was changed to Canon Camera Company in September 1947, the lens name was also changed to Canon Lens.

Of the numerous lenses produced by Canon since the X-ray Serenar lens, one that deserves comment is the 50mm f/0.95 lens made for the Canon 7 camera as being the fastest production lens for a 35mm camera from the time of the announcement of this ultra high-aperture lens in 1960 to present. Its most recent product of interest is the plastic-glass, 4 element aspheric 38mm f/2.8 lens for its Sureshot II 35mm auto-focus camera.

Chinon Industries, Inc.

This company was started in the summer of 1948 by Hiroshi Chino as Sanshin Seisakusho in Chino City, manufacturing lens barrels and mounts for major camera companies like Olympus, Ricoh, Yashica, etc. Around 1959 it developed its first 8mm cine Zoom lens and started production of photographic lenses. The company name was changed to Chinon Industries in January 1973. Currently its optical division makes lenses for the Chinon brand cameras, as well as a variety of zoom lenses for video cameras.

Fuji Photo Film Company, Ltd.
(Fuji Shashin Film K.K.)

This company started with the intention of producing photosensitized material in January 1934. By 1938, it announced to the public that it would tackle all photographic hardware, including the melting of optical glass and photographic objectives. During the war, it made aerial cameras and photographic objectives. After the war, it again concentrated on high-grade optical glass

manufacture as well as studio camera lenses. These were marketed under the trade name of "Rectar" and were patterned after the 4 element Carl Zeiss "Tessar" design.

For the consumer product application, Fuji marketed the 75mm and 83mm f/2.8 "Pentrectar" lens and the "Cristar" series for the 35mm cine camera application. All the lens names were consolidated in 1954 and renamed "Fujinar" and "Fujinon."

Konishiroku Shashin Kogyo K.K.

Konishiroku started as Konishi-Honten in 1873 and was also known as Rokuohsha, a divison of Konishi-Honten established in 1902 to produce photo-sensitive materials and later cameras, lenses, and other photo related apparatus. Currently it is known as the Konica Camera Company in the U.S.

In 1928, Hirowo Mohri began designing a photographic lens patterned after the German Carl Zeiss "Tessar" and, by the spring of 1931 produced an f/4.5, 4 element H type lens using Jena glass, named "Hexar." The Hex does not indicate the number of elements but comes from the founder's name, Rokuemon Sugiura—the Roku meaning six. The design was quite a success and claimed performance equal to the original Tessar lens. The 13.5cm f/4.5 Hexar Ser. 1 was first used on the Tropical Lily, announced by Konishiroku in June 1931. The Hexar name was used for the 4 element "Tessar" type lens of many different focal lengths with f/6.3, f/4.5, f/3.8, and f/3.5 apertures as Konishiroku's premium quality lens up to about 1959. After this time, as the lens construction became more complex, the name was changed to Hexanon which is still used today.

As described in the Asahi section, Konishiroku had a line of triplets called "Optor" which also came in many sizes and as f/6.3 and f/4.5. Much of the Optors were subcontracted to Asahi but, to our knowledge, the Hexars were usually produced in-house. The possible exception was the "Color Hexar" used on the 1970 Sakura Pak 100 and 300 126 cameras or the 1976 lens used on the Konica Pocket 400 110 camera. The lens on the Sakura Pak 100 was a 42mm f/11 plastic singlet, the 300 lens was a 38mm f/5.6 triplet, and the 400 "Color Hexar" a 28mm f/8.0 triplet.

In December 1951, the Konica II 35mm camera was announced with the new 5 element "Hexanon" lens. Since that time, all 4 or more element Konishiroku photographic lenses bear the name "Hexanon."

Minolta Camera Company, Ltd. (Minolta Camera K.K.)

In 1928, this company was started as the Nichi-Doku (means Japan-German) Shashinki Shokai by Mr. Kazuo Tashima. In 1931, the name was changed to Molta Goshi Kaisha and again changed to Chiyoda Kogaku Seiko K.K. in 1937. This was the year that Minolta started to manufacture lenses, and the first lens with the familiar name "Rokkor" appeared on a portable aerial camera made by Minolta in 1940. It was a 200mm f/4.5 "Rokkor" copied after the Carl Zeiss "Tessar" lens

and used on the model 100 SK aerial camera. By order of the Imperial Japanese Navy, Minolta started to develop and produce optical glass at Itami, near Kobe City, in 1942.

The first consumer product application was the 75mm f/3.5 "Rokkor" used on the Minolta Semi IIIA camera built in 1946. This was the first time anti-reflection coating was used on a Japanese made camera lens.

As mentioned under Asahi Kogaku, lenses for Minolta cameras prior to the "Rokkor" were purchased from outside. According to the Minolta Camera Annual dated December 1, 1963, Minolta Semi IIIA also came with "Promar" and "Zuiko" lenses. The 1951 Minolta Semi P and the 1953 Minoltacords also came with "Promar" 75mm f/3.5 lenses. These lenses are triplets as compared to the 4 element design named "Promar" on the Minolta Semi IIIA and earlier cameras.

Nippon Kogaku Kogyo Kabushiki Kaisha

This company is also pronounced Nihon Kogaku Kogyo K.K. and popularly known as the producer of the Nikon cameras and Nikkor lenses. World War I that shook the world in 1914 became the catalyst for consolidating three companies in 1917 to form the Nippon Kogaku Kogyo K.K. to meet the needs of the Imperial Japanese Navy. They were the optical division of Tokyo Keiki Seisaku Sho, Iwaki Glass Seisaku Sho and the earlier mentioned Fujii Lens Seizo Sho. In 1921, eight German engineers and scientists were hired with a five year contract to advance the optical technology at Nippon Kogaku. They were:

Max Lang, *Optical Design*
Hermann Dillmann, *Optical Computing*
Ernst Bernick, *Mechanical Engineering*
Heinrich Acht, *Product Design and Drafting*
Otto Stange, *Product Design and Drafting*
Adolf Sadtler, *Lens Grinding and Polishing*
Karl Weise, *Lens Grinding and Polishing*
Albert Ruppert, *Prism Grinding and Polishing*

Heinrich Acht extended his stay and returned to Germany in 1928. His last three years at Nippon Kogaku were spent as a lens designer and during this time, he developed and produced samples of photographic lenses from 7.5cm to 50cm with apertures from f/2.0 to f/6.8. The 50cm f/4.8 lens designed by Acht was named "Flieger Objective". These lenses were the first lenses made by Nippon Kogaku. In 1929 after Acht's departure, Kakuno Sunayama became the center of the lens design activities and soon completed an improved 50cm f/4.8 aerial lens and named it "Trimar." Also in 1929 he produced samples of a 12cm f/4.0 "Tessar" type lens for the 6.5x9cm plate camera and called it "Anytar". It was in 1932 that the name "Nikkor" was chosen for all Nippon Kogaku photographic objectives. It is well known by most serious camera collectors that all of the pre-World War II Canon cameras used "Nikkor" lenses. Also

famous is the story of *Life* photographer David Duncan who obtained a 50mm f/1.5 and a 135mm f/3.5 "Nikkor" for his Leica IIIF and shot the Korean conflict photos that made Nippon Kogaku and "Nikkor" famous outside Japan. In 1950, the 50mm f/1.5 was improved and became the first f/1.4 aperture 35mm high quality lens of this era to be mass produced. Both designs use the 50mm f/1.5 Carl Zeiss Sonnar designed by L. Bertele as a starting point. After marketing the now famous Nikon camera in October 1948, the name Nikon and Nikkor have become synonymous with quality cameras and lenses.

Olympus Optical Company, Ltd. (Olympus Kogaku Kogyo K.K.)

This company was started as a microscope manufacturer in 1919 under the name of Takachiho Seisaku Sho. In June 1936, it succeeded in making its first photographic objective, a 75mm f/4.5 which, like most others in Japan, was patterned after the German Carl Zeiss "Tessar" lens. A company-wide naming contest yielded the name "Zuiko" which became the name for all subsequent photographic lenses made by this company. "Zuiko" lenses enjoyed an excellent reputation for their optical performance as well as solid construction, both before and after World War II, and can be found on not only its own cameras, but also cameras made by Mamiya, Elmo, Aires, Walz, etc. In 1949, it changed its name to Olympus Kogaku Kogyo K.K. which continues to the present.

Petri Camera Company

This company was started as Kuribayashi Seisaku Sho in 1907 as a photographic accessory manufacturing plant and did not start camera production until 1919. It started lens fabrication in 1942 and has continued to produce lenses for its own cameras ever since. Prior to World War II its camera brand name was "First." It also called its lenses by the same name. After the war, it used the name "Orikkor" and "Orikon". Later the name was consolidated with the camera name and changed to "Petri".

Unfortunately, Petri Camera K.K. declared bankruptcy in 1977, but the company union members decided to continue to keep the factory operating. Some new cameras appeared after this date, until it too failed in 1979.

Tokyo Optical Company, Ltd. (Tokyo Kogaku Kikai K.K.)

This company was started by Hattori Tokei Ten (a clock-watch manufacturer) in September 1932 under the direction of the Imperial Japanese Army by merger of the Katsuma Kogaku Kikai Seisaku Sho, which was at the time a sub-contractor to Hattori Tokei, together with the optical division of the Seikosha factory of Hattori Tokei to manufacture photographic lenses, precision optical

mechanical instruments, and machinery. By 1934 it had produced triplet photographic lenses called "State" and "Toko" in f/6.3 and f/4.5 apertures. In 1937 it completed its first "Tessar" type 4 element design and named it "Simlar."

In 1940, it perfected a 50mm f/1.5 that had the front half of the Carl Zeiss "Sonnar" and the rear half of the Carl Zeiss "Biotar" design. This too was named "Simlar." The optical designer of the "Simlar" f/1.5, Ryoji Tomita, continued his development efforts and completed a 50mm f/0.7 design in 1944, which was later sold to the U.S. Occupation forces. The best-known usage of Tokyo Kogaku lenses are the 60mm f/3.5 "Toko" lens on the pre-war black Minion and post-war chrome Minion, as well as the 50mm f/1.5 "Simlar" on the Leotax DIV marketed from 1950 to 1953. For the Leotax F of 1954, the name had been changed to "Topcor," and all Topcon SLR cameras come equipped with lenses with the "Topcor" name, such as the Auto-Topcor, UV Topcor, etc.

Tomioka Optical Company, Ltd.

In 1924, Masashige Tomioka started a laboratory called Tomioka Kogaku Kenkusho in the Shinagawa district of Tokyo to develop photographic lenses. After a long duration of trial and error, he finally completed a 4 element f/4.5 "Tessar" type photographic lens using only Japanese-made glass and named it "Lausar." In 1932 the laboratory was changed to a manufacturing facility and named Tomioka Kogaku Kikai Seizosho. From 1933, it became OEM lens manufacturer for camera companies such as the Proud K.K.

After the war, it switched to the mass market and developed a triplet called "Tri-Lausar" for cameras like the Pigeon 35, Toyoca-6, Beautycord S, Yashimaflex B, etc. From late 1949, it has become exclusive lens suppliers for the Yashica Company, Ltd., and currently produces most of the lenses for the Yashica cameras.

It is interesting to note that most of the Japanese lens manufacturers had started by copying the Carl Zeiss "Tessar" formula as their first high-quality photographic objective. The aforementioned "Hexar," "Promar," "Anytar," "Zuiko," "Lausar," "Simlar" and "Rokkor" all fall into this category. It was in the mid 1950s that the Japanese lens makers raced to see who could come out with the fastest lens for their 35mm cameras. There was the 50mm f/1.2 Canon lens, 50mm f/1.2 Fujinon lens, 50mm f/1.1 Zunow lens (by a short-lived Zunow Kogaku K.K.), 50mm f/1.1 Nikkor, and finally the 1960 f/0.95 Canon lens that seemed to end the horsepower race. All of these lenses had something to be desired in terms of image quality and did not compare favorably to the f/2.0-f/1.7 lenses marketed by the respective companies. Although f/1.2 lenses were available for the SLR cameras of the mid 1960s, it was in 1969 that Canon announced their Canon FL 55mm f/1.2AL lens using an aspheric surface in one of their 7 elements to produce a high

performance high aperture lens. Until this time, the only commercially available high-aperture, high performance lens was the 1965 Leitz "Noctilux" with two aspheric surfaces on 6 element construction for the Leica M series cameras.

Lens makers of the 1970s and 1980s

For the past two decades, Japan has become the world leader in the photographic-optics field. A glance through a photographic periodical will reveal the numerous brands of cameras and lenses made in Japan. In 1984, without counting the major camera manufacturers outlined above, there are over twenty lens manufacturers producing various lenses for the 35mm SLR and other inter-changeable camera lenses. In alphabetical order they are:

Company Name	Brand Name
Ace Optical Co., Ltd.	ACETAR
Cima Kogaku Co., Ltd.	CIMKO
Kawakami Seiki Seisakusho, Ltd.	KAWANON
Kenlock Corporation	KENLOCK
Kimura Seimitsu Kogyo Co., Ltd.	KIMUNOR
Kino Precision Industries, Ltd.	KIRON; PANAGOR
Komine Co., Ltd.	
Kowa Co., Ltd.	KOWA
Makina Optical Co., Ltd.	MAKINON
Mitake Optical Co., Ltd.	EYEMIK
Nakadai Kogaku Co., Ltd.	
Nissin Koki Co., Ltd.	PROMURA; HI-LUX
Ozone Optical Co., Ltd.	OZUNON
Sankeisha and Co., ltd.	
Sanko Optical Co., Ltd.	SANKOR
Seimax Corp.	SEIMAX;SEIMAR
Sigma Corp.	SIGMA
Soligor Corp.	SOLIGOR
Sun Lens, Inc.	SUN
Tamuron Co., Ltd.	TAMURON
Tokina Optical Co., Ltd.	TOKINA
Yamasaki Optical Co., Ltd.	CONGO, ALTO

We are sure that there are other companies that the authors have missed but this list gives the readers an idea of the vast number of lens suppliers in Japan at this time.

Takashi Hibi
Manager, Inspection Department,
Japan Camera and Optical Instruments Inspection
 and Testing Institute

William S. Fujimura
Manager, Optics Design Engineering
Eastman Kodak Company

日本製カメラの変遷

**THE
EVOLUTION
OF THE
JAPANESE
CAMERA**

Paperbacked rollfilms were introduced in the United States in 1894 and within a few years were widely available both in America and in Europe. The machinery needed to produce this product was expensive, and the infant Japanese photographic industry at the turn of the century did not have the capital needed to invest in such equipment. Rollfilms, therefore, had to be imported, making them expensive. Because of the distance they had to travel in slow un-air-conditioned freighters, they frequently were damaged by the heat and humidity, making them unreliable.

The first cameras produced in quantity in Japan for the amateur market used relatively inexpensive plates or sheet films manufactured domestically. The first model of the Cherry Portable Camera exhibited is a replica; there are no known surviving examples. It was produced by the predecessor firm of the Konishiroku Photographic Company, Ltd.

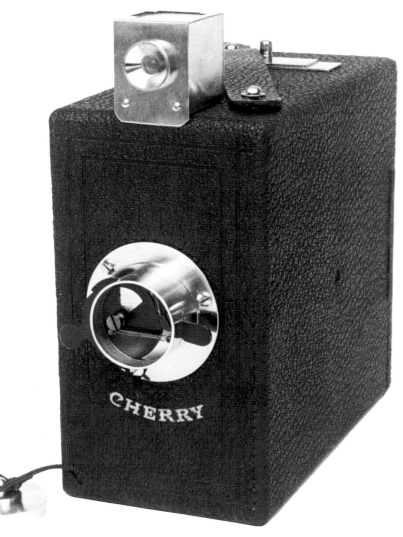

Cherry Portable Camera (Replica) 1903
See checklist page 18

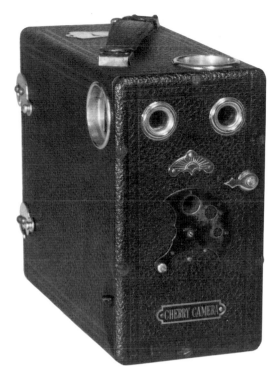

Cherry Portable Camera 1904
See checklist page 18

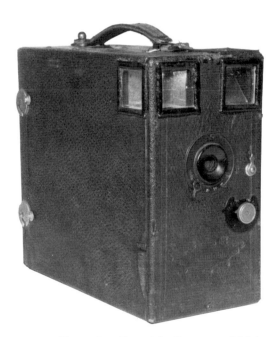

Champion Portable Camera 1904
See checklist page 18

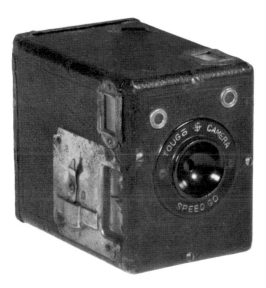

Tougo Camera 1930
See checklist page 21

Cherry Portable Camera (Replica) 1903
Konishi-Honten, Tokyo
84:141:1
International Museum of Photography at George
 Eastman House
Gift of Konishiroku Photo Industry Co., Ltd.,
 Tokyo

The Cherry was the first production camera mass produced in Japan for the amateur market. It was designed to use 2 ¼ x 3 ¼ inch dry plates that were changed with a simple drop plate mechanism.

Cherry Portable Camera 1904
Konishi-Honten, Tokyo
L84:061:1
Loaned by Mr. Mikio Awano, Nishinomiya City

Shortly after the introduction of the first model Cherry, an improved model was introduced with built-in finders and a disc-type aperture control.

Champion Portable Camera 1904
Konishi-Honten, Tokyo
L84:061:2
Loaned by Pentax Gallery, Tokyo

The Champion was a drop plate box camera capable of making 12 exposures on 3 ¼ x 4 ¼ inch dry plates. It was fitted with an iris diaphragm, the first camera to be so equipped in Japan.

Sakura Stereo Prano 1907
Konishi-Honten Co., Ltd, Tokyo
L84:061:3
Loaned by Konishiroku Photo Industry Co., Ltd.,
 Tokyo

The Sakura Stereo Prano was the first production stereo camera made in Japan. The design was similar to products made by the Rochester Optical Company. In fact, the lens and shutter assembly were made by this company.

Sakura Noble 1908
Konishi-Honten Co., Ltd., Tokyo
L84:061:4
Loaned by Japan Camera Inspection Institute,
 Tokyo

The large format Sakura Noble view camera was the first in Japan with an adjustable bed for making further optical corrections. Such features, which were standard in cameras made in the West, were beginning to appear on domestically made Japanese products.

**THE
EVOLUTION
OF THE
JAPANESE
CAMERA**

Pearl Hand Camera 1909
Konishi-Honten Co., Ltd., Tokyo
L84:061:5
Loaned by Japan Camera Inspection Institute,
 Tokyo

The Pearl Hand Camera is a copy of the No. 3 Folding Pocket Kodak introduced in 1900. Even such features found on the Kodak as interchangeable backs for either rollfilm or individual plates were included. The lens and shutter were made by Wollensak in Rochester and imported into Japan.

Minimum Idea Camera 1911
Konishi-Honten Co., Ltd., Tokyo
L84:061:6
Loaned by the Japan Camera Inspection Institute,
 Tokyo

This was the first 2 ¼ x 3 ¼ inch folding camera to be made in Japan. The folding lever system was identical to that used on the first model Folding Kodak earlier in the century.

Star Watch Camera 1912
Ueda Syashinkiten, Osaka
L84:061:7
Loaned by Japan Camera Inspection Institute
 Camera, Tokyo

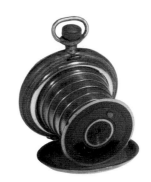

This is a copy of the Lancaster Watch camera
made in England about twenty years earlier. A
series of decreasing diameter sections folded into
each other, collapsing the camera. When folded, it
resembled a typical pocket watch. Small dry plates
and special holders were used.

Flex 1913
FMP Society, Tokyo
L84:061:8
Loaned by Pentax Gallery, Tokyo

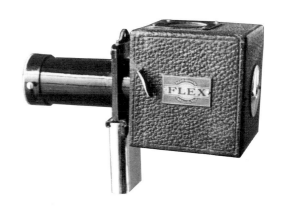

The Flex was a simple little tintype camera. After
sensitizing the enameled metal plate, it was
inserted in the camera and raised into the focal
plane. The developing chemical was contained in
the small tank mounted under the lens. A lever
lowered the exposed tintype into this tank. The
one inch diameter round images produced by this
camera were held in clasps and intended to be
worn as jewelry.

Lily Hand Camera—Model II 1916
Konishi-Honten Co., Ltd., Tokyo
L84:061:9
Loaned by Japan Camera Inspection Institute,
 Tokyo

The Lily Hand Camera was nearly identical in
overall design to a number of cameras made in
Germany, England, and the United States at this
time. Called either field or view cameras, they
were generally used by professionals or serious
amateurs.

A rising front lens board to correct for optical
distortion was a must for serious photographers
and this feature first appeared in a camera of
Japanese manufacture on the Lily Hand Camera.

The negative lens and post type of viewfinder
were also used for the first time in Japan on the
Lily.

Sweet Camera 1918
Sone-Syunsuido Co., Tokyo
L84:061:10
Loaned by Japan Camera Inspection Institute,
 Tokyo

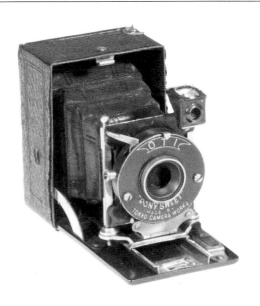

Sensitized materials, whether imported or of
domestic manufacture, were expensive in Japan at
this time. A number of the cameras in this exhibit
were designed to increase the number of expo-
sures on a roll by the use of a reduced format. The
Sweet is an example of the same strategy applied
to a folding plate camera. Standard size 3 ¼ x 4 ¼
inch dry plates could be cut by the user into quar-
ters and fitted in the special holders made for this
camera. It was probably the smallest camera of
this type made in the world.

日本製カメラの変遷

**THE
EVOLUTION
OF THE
JAPANESE
CAMERA**

Pearl Hand Camera—Model 2 1923
Konishiroku-Honten Co., Ltd., Tokyo
L84:061:11
Loaned by Japan Camera Inspection Institute,
Tokyo

The Pearl Hand Camera—Model 2 was the first camera of any type to be made in Japan for 120 rollfilm. At this time, all paper-backed rollfilms had to be imported and were relatively expensive. The domestic industry produced only plates and sheet films.

Secrette 1923
Sone-Syunsuido Co., Tokyo
L84:061:12
Loaned by Japan Camera Inspection Institute,
Tokyo

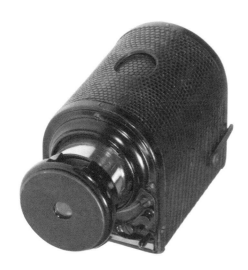

Deceptive angle cameras that mimicked other instruments became popular before the turn of the century with the invention of dry plates. French and then German manufacturers made a camera in the form of a monocular telescope. What appears to be a viewing lens is a piece of blanked out plane glass. The picture is actually taken at right angles to the apparent direction the instrument is pointed. The finder in the "eye piece" has a mirror to correct the viewing angle. Exposures were made on individual glass plates. This was the first Japanese imitation of this camera type.

Pearlette 1925
Konishiroku-Honten Co., Ltd., Tokyo
L84:061:13
Loaned by Japan Camera Inspection Institute,
Tokyo

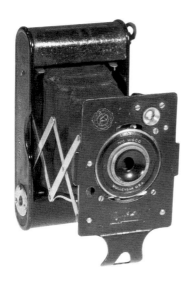

The Pearlette is almost an exact copy of the Vest Pocket Kodak. This camera design was one of the most famous and successful in the world, and frequently imitated. It was copied with only slight changes in Germany, France, England and Japan. 127 film was originally introduced for this camera and is still in production today although no cameras using this format are still being made. Like the Vest Pocket Kodak, the Pearlette went through a number of model changes during its long production history.

Record 1926
Konishiroku-Honten Co., Ltd., Tokyo
L84:061:14
Loaned by Japan Camera Inspection Institute,
Tokyo

The Record was a curious cross between a 35 mm and a box type camera, and showed a great deal of ingenuity. Paperbacked unsprocketed 35 mm film was used and 12 exposures, each 22 x 32 mm, could be made on a roll. As on most simple box cameras, there were very few adjustments.

Idea Spring 1926
Konishiroku-Honten Co., Ltd., Tokyo
L84:061:15
Loaned by Japan Camera Inspection Institute,
Tokyo

Very large format folding cameras were popular with press photographers throughout the world. This type of four-strut instrument had been popularized by several German firms. The image size was about 5 x 7 inches, but when folded, the camera was reasonably portable. The Idea Spring was the first to be made in Japan of this type.

Neat Reflex 1926
Konishiroku-Honten Co., Ltd., Tokyo
L84:061:16
Loaned by Japan Camera Inspection Institute,
 Tokyo

Large format single lens reflex cameras were very popular at this time. In this country, the Graflex was an industry standard. A number of firms in England and Germany also made similar cameras. They shared a number of common characteristics such as focal plane shutters and interchangeable lenses. This was the first of this general type to be made in Japan and the first to be fitted with a revolving back.

Tougo Camera 1930
Tougo Do Co., Ltd., Tokyo
L84:061:17
Loaned by Japan Camera Inspection Institute,
 Tokyo

The film for the Tougo camera was carried in individual paper holders. After exposure, the entire holder could be immersed in special developing and fixing agents. The film was processed without the need of a darkroom.

Nifca Dox 1930
Nichi-Doku Syashinki Shoten, Osaka
L84:061:18
Loaned by Japan Camera Inspection Institute,
 Tokyo

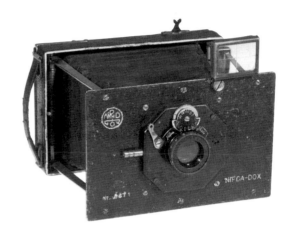

Nichi-Doku Syashinki Shoten was the first corporate name of the firm we now know as the Minolta Camera Company. It was an early manufacturer of compact, high grade folding cameras similar to many produced in France and Germany at this time. The Nifca Dox was a very economical version of this type of camera and the first in Japan with a lens with simple front element focusing.

Sakura Box Camera 1931
Konishiroku-Honten Co., Ltd., Tokyo
L84:061:19
Loaned by Japan Camera Inspection Institute,
 Tokyo

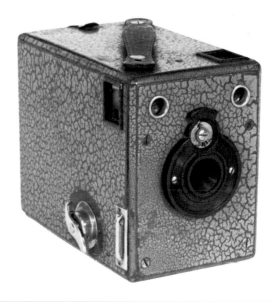

The firm of Konishiroku-Honten has changed its name slightly and now manufactures cameras sold under the Konica brandname. In 1931 they introduced two simple box cameras. This, the smaller of the two, used 127 rollfilm and made eight exposures, each 4 x 6.5 cm on a roll. Like the larger model, it was the first of its particular format of Japanese manufacture.

Sakura Box Camera 1931
Konishiroku-Honten Co., Ltd., Tokyo
L84:061:20
Loaned by Pentax Gallery, Tokyo

Simple box cameras, all nearly identical in appearance, were the favored tool of the amateur throughout the world. The Sakura was the first to be made in Japan for popular 120 rollfilm. Eight 6 x 9 cm exposures were made on a single roll.

日本製カメラの変遷

Pearl Hand Camera—Model 1931 1931
Konishiroku-Honten Co., Ltd., Tokyo
L84:061:21
Loaned by Japan Camera Inspection Institute,
Tokyo

The Pearl was a standard 120 folding rollfilm camera of a type made in at least a half dozen countries. This camera had several unusual features. It was the first to be made in Japan with dual format capability. A mask could be inserted to reduce the image size and extend the number of pictures possible on a roll. The Pearl also featured a curious type of remote shutter imported from Germany. A small pin was inserted in the shutter to which a thread was attached. Tugging gently on the thread tripped the shutter.

Arcadia Hand Camera 1931
Molta Co., Ltd., Osaka
L84:061:22
Loaned by Japan Camera Inspection Institute,
Tokyo

Before 1930, the Japanese camera industry was largely dependent on imported shutters for their high grade cameras. The Arcadia, introduced in the same year as the Happy and both made by the firm that is now known as the Minolta Camera Company, was the first to use a precision shutter of domestic manufacture.

Happy Hand Camera 1931
Molta Co., Ltd., Osaka
L84:061:23
Loaned by Japan Camera Inspection Institute,
Tokyo

Medium format cameras of this type were the preferred instruments of a large number of serious amateurs and professionals. They were reasonably compact and very sturdy. So many different manufacturers made cameras nearly identical in appearance that they have to be examined closely to tell which model you are looking at. The Molta Co. made several models of this style camera. The "Happy" was the first to be made in Japan with a built-in self timer. This 2 ¼ x 3 ¼ inch camera could be used with films, plates or filmpacks.

Pearl Camera—Model 1933 1933
Konishiroku-Honten Co., Ltd., Tokyo
L84:061:24
Loaned by Japan Camera Inspection Institute,
Tokyo

The Pearl had an all-metal body and was the first folding rollfilm camera to be manufactured in Japan with a self-erecting mechanism. This feature made the camera much easier for the amateur to use.

Olympic Jr. 1934
Olympic Camera Works, Tokyo
L84:061:25
Loaned by Japan Camera Inspection Institute,
Tokyo

The inexpensive Olympic Jr. was one of the two Japanese cameras introduced the same year to use 127mm film with a 3 x 4 cm format to permit a greater number of pictures per roll.

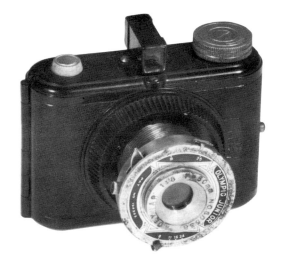

Baby Pearl 1934
Konishiroku-Honten Co., Ltd., Tokyo
76:17:5
International Museum of Photography at George
 Eastman House

The year this camera was introduced, 127 film was one of the most popular sizes in the world. Most cameras made for use with this film used the vest pocket 4 x 6.5 cm format. The Baby Pearl was the first folding design for the 3 x 4 cm format, which allowed 16 exposures to be made on a single roll, to be made in Japan. The body on the Baby Pearl is molded plastic.

Minolta 1934
Molta Co., Ltd., Osaka
L84:061:26
Loaned by Japan Camera Inspection Institute,
 Tokyo

This model and the Auto Minolta also on exhibit were the first of the Plaubel type strut cameras to be made in Japan. Both models were introduced the same year. This model was less expensive and did not have a coupled rangefinder. The unusual third strut for increased rigidity was found on both models. Other features remained the same.

Minolta Vest 1934
Molta Co., Ltd., Osaka
L84:061:27
Loaned by Japan Camera Inspection Institute,
 Tokyo

Folding cameras almost invariably used leather bellows. The Molta Co. was the first to use a system of decreasing size plastic sections, reinforced with metal, that collapsed into each other instead of a leather bellows. Otherwise, the camera was a basic 127 rollfilm type for two formats, either 4 x 6 or 3 x 4 cm.

Auto Minolta 1934
Molta Co., Ltd., Osaka
L84:061:28
Loaned by Japan Camera Inspection Institute,
 Tokyo

This type of folding camera is frequently called the Plaubel type. The front of the camera is extended on struts which also couple the optics to a rangefinder. In addition to the top and bottom struts, there is a third strut assembly on one side of the camera to provide extra rigidity. This may be the only time this system was ever employed in a production camera. The shutter was fitted with a safety switch to prevent accidental trippings.

Super Olympic 1935
Asahi Bussan Co., Ltd., Tokyo
L84:061:29
Loaned by Japan Camera Inspection Institute,
 Tokyo

This 35mm camera was the first to be manufactured in Japan to the 24 x 36 mm world standard format equipped with a leaf type shutter. The Bakelite body was molded in two sections.

Semi Minolta—Model I 1935
Molta Co., Ltd., Osaka
L84:061:30
Loaned by Japan Camera Inspection Institute,
 Tokyo

The 4.5 x 6 cm format was very popular for several decades before the war and has been revived only in recent years. The first camera to be made in Japan for this format was the Semi Minolta. It was also the first camera to be fitted with an accessory shoe. The between-the-lens shutter had an unusual feature. A small wheel rotated after each exposure, keeping track of the total number of times the shutter had been released.

日本製カメラの変遷

THE EVOLUTION OF THE JAPANESE CAMERA

The manufacture of paperbacked rollfilms began in Japan in the late 1920s, partially ending the dependence on imports that had existed for more than three decades. In 1930 the Mamiya Camera Company introduced the Mamiya Six, the first camera to be produced in Japan after the beginning of domestic rollfilm manufacture. The Mamiya organization correctly judged that the market for rollfilm cameras would expand significantly with the availability of lower-priced locally made films. The success of the Mamiya Six encouraged other makers to market cameras for use with rollfilms that were now readily available. At this stage in the development of the industry, most of the designs were copies or near copies of successful products made in either the United States or Germany. It was obvious that skilled engineers were at work and learning rapidly. Copying of successful designs was a universal process, not limited to Japan. Successful American cameras produced by the Eastman Kodak Company appeared in Germany, England, France, and Japan in only slightly altered form.

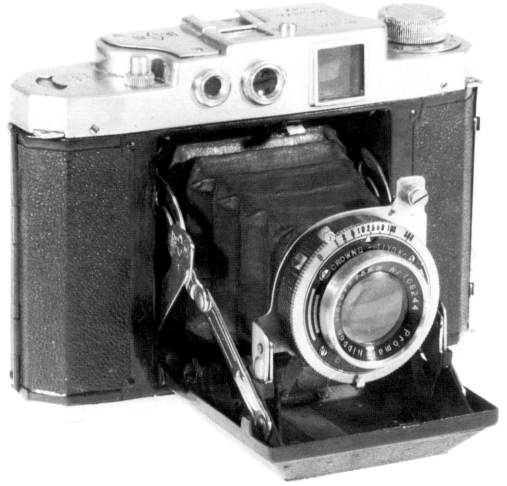

Mamiya Six Camera—Model I 1940
See checklist page 31

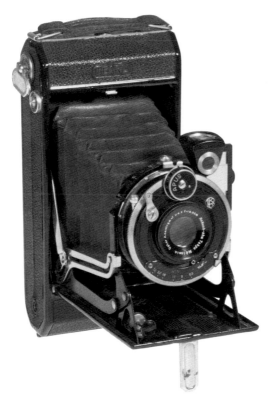

Pearl Camera—Model 1933 1933
See checklist page 22

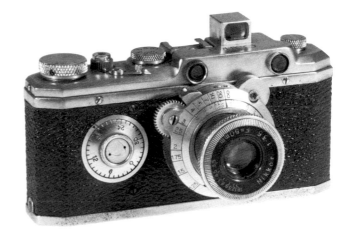

Hansa Canon Camera 1935
See checklist page 26

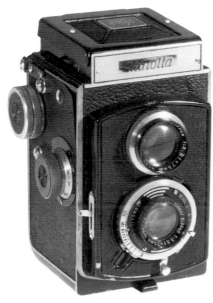

Minolta Flex Model I 1937
See checklist page 28

日本製カメラの変遷

THE
EVOLUTION
OF THE
JAPANESE
CAMERA

Sun Stereo 1935
Yamashita Tomojiro Shoten, Ltd., Tokyo
L84:061:31
Loaned by Pentax Gallery, Tokyo

The Sun Stereo was the first rollfilm stereo camera to be made in Japan. A total of 8 stereo pairs, each image measuring 4.5 x 6 cm, were made on a roll of 120 film.

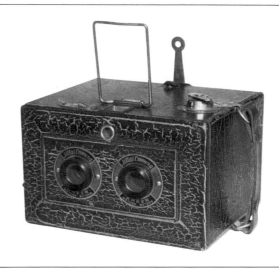

Hansa Canon Camera 1935
Seiki Kogaku Kenkyusho, Tokyo
L84:061:32
Loaned by Japan Camera Inspection Institute, Tokyo

The Hansa Canon was the first 35mm camera to be manufactured in Japan fitted with a focal plane shutter. In order to avoid infringing Leitz patents on the viewfinder/rangefinder system used with this type of camera, it was fitted with an unusual "pop-up" viewfinder.

Picny 1935
Miyakawa Seisakusho, Tokyo
L84:061:33
Loaned by Japan Camera Inspection Institute, Tokyo

The compact Picny made sixteen 3 x 4 cm exposures on a roll of 127 film. It was the first camera of Japanese manufacture with a collapsible lens mount.

Lily Hand Camera 1936
Konishiroku-Honten Co., Ltd., Tokyo
L84:061:34
Loaned by Japan Camera Inspection Institute, Tokyo

The Albada type of eye-level viewfinder was fairly popular in the 1930s. A partially mirrored optical surface reflected lines which framed the picture area back to the eye. The result was a particularly clear and bright viewing image. This type of finder made its appearance early in the century. The Lily was the first camera made in Japan to use this type of finder. The camera was of the folding plate or film type made by many manufacturers worldwide.

Semi First 1936
Kuribayashi Syashinki Seisakusho, Tokyo
L84:061:35
Loaned by Japan Camera Inspection Institute, Tokyo

The Compur shutter manufactured in Germany was one of the most successful shutter designs ever introduced. The Semi First was the first camera to be made in Japan with a shutter of this type manufactured by Seikosha, a firm in business today that still makes shutters but is far better known as the manufacturer of Seiko watches. The Semi First made sixteen 4.5 x 6 cm exposures on 120 rollfilm.

Mulber Six 1936
Kuwata Shokai Co., Osaka
L84:061:36
Loaned by Japan Camera Inspection Institute, Tokyo

The Mulber Six was similar in general appearance to the First Six. Like the First Six, the Mulber was of the self-erecting folding type with a Compur type shutter. It offered one extra feature, however. In addition to the 6 x 6 cm format, the user could insert a mask and make sixteen 4.5 x 6 cm exposures on a roll. Indents on the viewfinder indicated the different formats.

Minolta Six 1936
Molta Co., Ltd., Osaka
L84:061:37
Loaned by Japan Camera Inspection Institute,
 Tokyo

This was another of the 6 x 6 cm 120 rollfilm
cameras to appear this year, but it differed some-
what from the others. Instead of a self-erecting
collapsible lens mount, the Minolta Six featured an
unusual three section plastic "bellows."

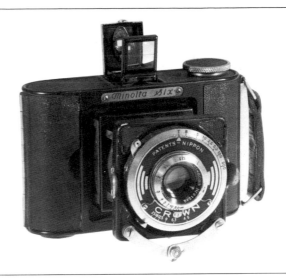

First Six 1936
Kuribayashi Syashinki Seisakusho, Tokyo
L84:061:38
Loaned by Japan Camera Inspection Institute,
 Tokyo

In the same year, 1936, three manufacturers mar-
keted 120 rollfilm cameras for serious amateurs.
Each made 12 exposures, 6 x 6 cm square, on a
single roll of film, the first cameras of Japanese
manufacture for this format. The First Six was a
traditional folding camera with a self-erecting
front and a Compur type shutter.

Meisupi 1937
Togodo Photo Industry, Tokyo
L84:061:39
Loaned by Japan Camera Inspection Institute,
 Tokyo

The Togodo Photo firm made several different
models of an unusual side-by-side twin-lens reflex.
The later model also used a special paperbacked
form of 35mm film. The first model used either
film contained in special paper holders, each with
their own dark slide, or special film packs.

Midget 1937
Misuzu Shokai, Ltd., Tokyo
L84:061:40
Loaned by Japan Camera Inspection Institute,
 Tokyo

The Midget was the first of the very subminiature
cameras made in Japan designed in the shape of a
regular size camera. Ten exposures, each 14 x 14
mm, were made on a special paperbacked rollfilm.

Prince Flex 1937
Fukada Shokai, Ltd., Osaka
L84:061:41
Loaned by the Pentax Gallery, Tokyo

This was the first camera of Japanese manufacture
of the twin-lens reflex type pioneered by Rollei-
flex in Germany. Twelve exposures each 6 x 6 cm
square were made on 120 rollfilm. The focusing
mount was a lever actuated helical gear.

Sakura 1937
Konishiroku-Honten Co., Ltd., Tokyo
84:061:42
Loaned by Japan Camera Inspection Institute,
 Tokyo

The very simple Sakura had a molded Bakelite
body and a wire-frame type of viewfinder. It was
the only camera besides the Minion to use the
unusual 4 x 5 cm format. Ten exposures could be
made on a roll of 127 film.

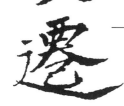

THE
EVOLUTION
OF THE
JAPANESE
CAMERA

Super Semi-Proud 1937
Proud Co., Ltd., Tokyo
L84:061:43
Loaned by Mr. Toshio Noma, Osaka

The Super Semi-Proud used a very precise type of helical focusing mount which was coupled to the rangefinder by means of a cam actuated lever. This was the first use in Japan of this system.

Weha Chrome Six 1937
Yamamoto Camera Co., Ltd., Osaka
L84:061:44
Loaned by Japan Camera Inspection Institute, Tokyo

In the middle 1930s, the Carl Zeiss organization in Jena, Germany, had developed a system that simplified the process of coupling a rangefinder to a camera with a collapsible lens. It was used most frequently on folding cameras. The Weha was a 120 rollfilm camera fitted with a lens that was moved about two inches away from the body in the taking position. The Zeiss type of rangefinder was used eliminating the need for a mechanical linking of the rangefinder mechanism and the optical system. This was the first use in Japan of this type of coupled rangefinder.

Auto Semi Minolta 1937
Chiyoda Kogaku Seiko K.K., Osaka
L84:061:45
Loaned by Japan Camera Inspection Institute, Tokyo

The Auto Semi Minolta was the first camera made in Japan that coupled a rack and pinion type of focusing mechanism to a rangefinder. It used paperbacked 120 rollfilm. An automatic stop simplified film advance.

Auto Press Minolta 1937
Chiyoda Kogaku Seiko K.K., Osaka
L84:061:46
Loaned by Japan Camera Inspection Institute, Tokyo

The Auto Press Minolta followed the general design of the Plaubel Makina made in Germany but incorporated a number of useful refinements that did not appear on the Plaubel until later. It was fitted with a coupled rangefinder and one of the earliest cordless brackets for flash photography. The interchangeable backs permitted the use of rollfilm, cut film, or film packs.

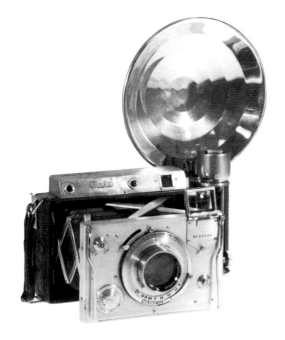

Minolta Flex—Model I 1937
Chiyoda Kogaku Seiko K.K., Osaka
L84:061:47
Loaned by Japan Camera Inspection Institute, Tokyo

This was the first twin-lens medium format reflex camera made in Japan with a double exposure prevention mechanism. The design was otherwise traditional and followed a general world pattern.

Minion 1938
Tokyo Optical Company, Ltd., Tokyo
L84:061:48
Loaned by Japan Camera Inspection Institute,
 Tokyo

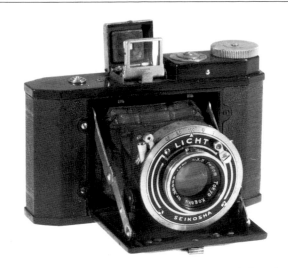

The Minion was one of the two cameras ever
made in the world, both in Japan, with a 4 x 5 cm
format. Ten exposures could be made on a roll of
127 film. The exposure counter was quite
advanced. After the first number had been lined
up in the red window, subsequent frames were
indicated by a counter on top of the camera.

Guzzi 1938
Earth Optical Co., Ltd., Tokyo
L84:061:49
Loaned by Japan Camera Inspection Institute,
 Tokyo

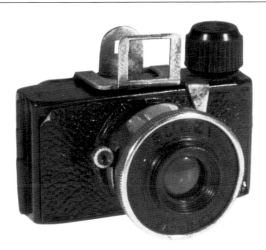

The little Guzzi was really a novelty camera, but it
was one of the first subminiatures to be made in
Japan. The format was unique. A special paper-
backed 20mm rollfilm was used to make ten
18 x 18 mm exposures.

Tsubasa Super Semi 1938
Optochrome Co., Ltd., Tokyo
L84:061:50
Loaned by Japan Camera Inspection Institute,
 Tokyo

With a leaf-type of shutter, the tripping mech-
anism is mounted on the shutter housing. On the
earliest cameras fitted with shutters of this type, it
was necessary to fire the shutter by pressing this
lever. It is much more convenient if the camera is
fitted with a remote release of some type. The
release on the Tsubasa is of the "trigger-type" that
was first used on the German-made Voightlander
Bessa.

Baby Super Flex 1938
Kikodo Co., Ltd., Tokyo
L84:061:51
Loaned by Japan Camera Inspection Institute,
 Tokyo

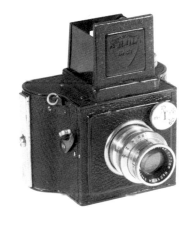

The Baby Super Flex was a single-lens reflex and
the first in Japan that used 127 rollfilm. A very
simple mechanism raised the mirror out of the
focal plane and tripped the shutter. The lenses
were interchangeable.

日本製カメラの変遷

THE
EVOLUTION
OF THE
JAPANESE
CAMERA

Boltax 1938
Miyakawa Seisakusho Co., Tokyo
L84:061:52
Loaned by Japan Camera Inspection Institute,
 Tokyo

The very small Boltax used a special form of
35mm film with paper leaders to make twelve 24
x 24 mm exposures on a roll. It was certainly the
smallest 35mm camera made at this time in Japan.
The design was based on a camera of German
manufacture made several years earlier.

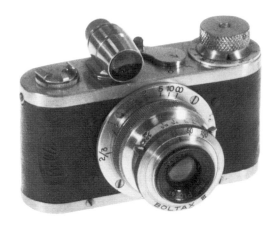

Ricohl 1938
Riken Kogaku Kogyo, Tokyo
L84:061:53
Loaned by Japan Camera Inspection Institute,
 Tokyo

Focal plane shutters were rarely used on eye-level
miniature cameras at this time for any format
except 35mm. The Ricohl was an exception. This
127 rollfilm camera looked like and handled like a
35mm camera and was fitted with a focal plane
shutter. The relatively large 3 x 4 cm images were
preferred by a number of photographers.

Hamondo—Model B 1938
Maruso Kogaku Co., Kyoto
L84:061:54
Loaned by Japan Camera Inspection Institute,
 Tokyo

The Hamondo ranks as one of the most unusual
combination of a camera and a pair of binoculars.
Most designs of this type used the binocular por-
tion of the instrument as a viewfinder. On the
Hamondo, the binoculars are mounted at a right
angle to the camera's lens and are totally unrelated
to the picture taking process. It was simply a
means of combining two separate instruments in a
single package.

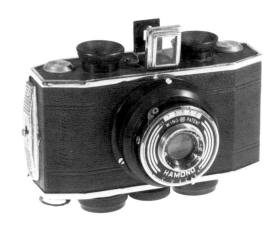

Canon Jr. 1939
Seiki Kogaku Kogyo, Tokyo
L84:061:55
Loaned by Japan Camera Inspection Institute,
 Tokyo

The Canon Jr. was the first Japanese made copy of
the German Leica with a thread mount for the
interchangeable lenses that was identical to that
used by the Leica. This was the only 35mm cam-
era ever made by Canon that did not have a range-
finder. Very few were made.

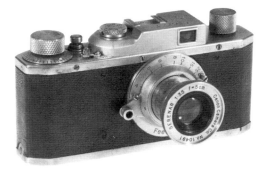

Lyrax 1939
Fuji Kogaku Kogyo, Tokyo
L84:061:56
Loaned by Japan Camera Inspection Institute,
 Tokyo

The Lyrax was the first camera of Japanese manu-
facture to be fitted with an integral rangefinder. It
was not coupled to the lens on this early model. A
separate reading was made and the information
transferred to the distance scale on the lens. This
model used 120 rollfilm and made 16 exposures,
each 4.5 x 6 cm, on a roll.

Leotax 1940
Showa Kogaku Seiki, Ltd., Tokyo
L84:061:57
Loaned by Mr. Mikio Awano, Nishinomiya City

The Leotax was a copy of the basic Leica 35mm camera, however, the rangefinder was not coupled to the lens. The coupling mechanism was covered by a Leitz patent so, on the Leotax, a distance reading is taken with the rangefinder and transferred manually to the lens.

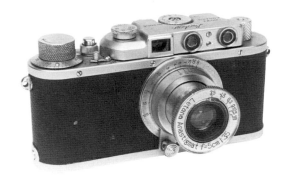

Meikai 1940
Tougodo Photo Industry, Tokyo
L84:061:58
Loaned by Japan Camera Inspection Institute,
 Tokyo

The Meikai was an unusual combination of a number of ideas. Paperbacked sprocketless 35mm film yielded 16 exposures, each 30 x 40 mm, on a roll. It was a true twin-lens reflex with the taking and viewing lenses mounted side by side. This unusual positioning of the optics was unique in a camera of this format and used only on several Japanese-made instruments.

BB Semi First 1940
Kuribayashi Syashinki Seisakusho, Tokyo
L84:061:59
Loaned by Japan Camera Inspection Institute,
 Tokyo

The BB Semi First was the first camera made in Japan with an exposure meter fitted to the camera. A simple extinction type of meter, with a scale to convert the values to exposure data, was permanently attached to the camera.

Mamiya Six Camera—Model I 1940
Mamiya Camera Co., Ltd., Tokyo
76:017:4
International Museum of Photography at George
 Eastman House

This folding 120 rollfilm camera incorporated a number of mechanically sophisticated features. The focussing was accomplished by moving the film at the focal plane which was attached to a coupled rangefinder. It was one of the earliest cameras to be fitted with a double exposure warning device. After making an exposure, a red warning signal appeared in the viewfinder.

Shinko Flex 1940
Yamashita Shokai Co., Osaka
L84:061:60
Loaned by Japan Camera Inspection Institute,
 Tokyo

This was the first camera made in Japan of the single-lens reflex type for medium format photography. It used 120 rollfilm and made twelve 6 x 6 cm exposures on a roll. The lenses were interchangeable.

Auto Keef 1941
Kokusaku Seiko Co., Ltd., Tokyo
L84:061:61
Loaned by Japan Camera Inspection Institute,
 Tokyo

This camera, designed to use 127 rollfilm, had a collapsible lens mount and a somewhat unusual type of shutter release mechanism. A body release button, combined with a collapsible lens mount with a leaf type shutter, requires a complex mechanical system to connect the release to the shutter. The Auto Keef has a small housing attached to the side of the shutter with a button easily operated by the forefinger. The housing also served as a means of keeping the camera level when it was placed on a flat surface.

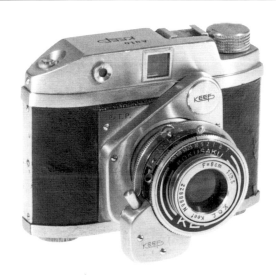

日
本
製
カ
メ
ラ
の
変
遷

**THE
EVOLUTION
OF THE
JAPANESE
CAMERA**

In the years immediately following the Second World War, the Japanese camera industry concentrated on the struggle to rebuild. Extreme shortages of essential materials imposed severe limitations on both the quantity and quality of cameras that could be produced. As shortages eased, production increased and a steady stream of cameras began to appear. Designs introduced after the war varied little or not at all from pre-war models. The effort to rebuild the basic plant took precedence over the creation of new models. The market at this time was primarily domestic, plus the Allied occupation forces. There were no organized export efforts, and the Japanese-made cameras that did find their way to this country were generally brought home by returning servicemen.

During this period, an issue of great importance to the industry was resolved. The world standard 24 x 36mm format for 35mm photography had not been accepted by all Japanese manufacturers. Several companies began to produce cameras with a non-standard smaller format. The smaller format was popular in Japan because it reduced film costs and could be enlarged without cropping to several standard paper sizes. However, it was incompatible with processing equipment in place in North America and Europe. Under pressure from the occupation authorities, the companies agreed to change to the standard 24 x 36mm format. The recognition and resolution of this problem took place over a very short period of time, so only a handful of cameras were built to the non-standard format.

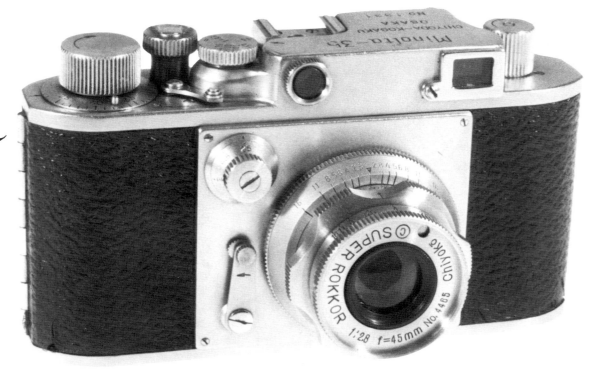

Minolta 35 Camera 1947
See checklist page 34

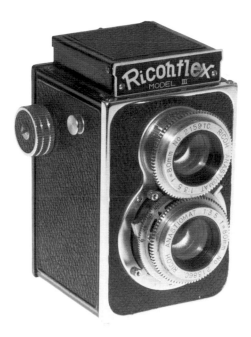

Ricohflex—Model III 1950
See checklist page 38

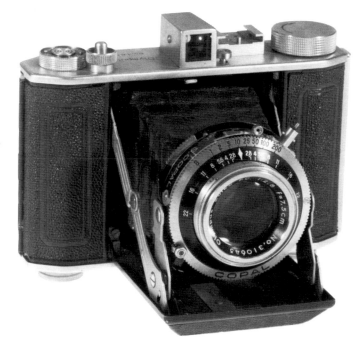

Olympus Chrome Six Camera—Model 3 1952
See checklist page 40

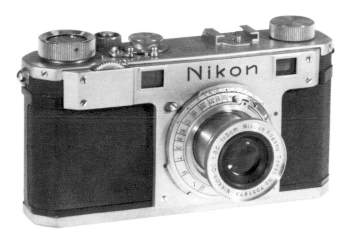

Nikon I 1948
See checklist page 36

日本製カメラの変遷

**THE
EVOLUTION
OF THE
JAPANESE
CAMERA**

Mamiya Six—Model III 1941
Mamiya Camera Co., Ltd., Tokyo
L84:061:62
Loaned by Japan Camera Inspection Institute,
 Tokyo

As flash photography became popular, camera manufacturers worked out various means of synchronizing the shutter on the camera to the flash gun. Internal synchronization involves the use of an electric contact in the shutter with an external post which was wired to the flashgun. The Mamiya Six—Model III was the first Japanese camera with a single post type of flash synchronizer. This meant that any type of flashgun that could be attached and grounded to the camera could be used.

Minolta Flex Automat 1941
Chiyoda Kogaku Seiko K.K., Osaka
L84:061:63
Loaned by Japan Camera Inspection Institute,
 Tokyo

Rolleiflex cameras made in Germany employed a crank operated film advance system that automatically indexed the film after each exposure, thus eliminating the need for the little red window and the tedious and slow process of advancing the film. The Minolta Flex Automat was the first Japanese-made camera to use the "Rolleiflex" system. This method of advancing the film was so superior that it became virtually an industry standard.

Minolta Semi III-A 1946
Chiyoda Kogaku Seiko K.K., Osaka
L84:061:64
Loaned by Japan Camera Inspection Institute,
 Tokyo

The Minolta Semi III-A was one of the first cameras to be manufactured in Japan after the war. Based on a pre-war design, it incorporated several improvements, the most important of which was its coated lens. This was the first camera with coated optics to be made in Japan. It used standard 120 film and made 16 exposures, each 4.5 x 6 cm, on a roll.

Steky 1947
Riken Optical Industries, Ltd., Tokyo
L84:061:65
Loaned by Japan Camera Inspection Institute,
 Tokyo

The Steky was the first subminiature camera to be made in Japan after the war. In addition to the standard, a medium telephoto lens was available. The Steky was very well made and popular. Riken Optical made a number of different models with extra features. The 16mm film used by the Steky was contained in special cassettes. Twenty exposures, each 10 x 14 mm, were made on a roll.

Minolta 35 Camera 1947
Chiyoda Kogaku Seiko Co., Ltd., Osaka
L84:061:66
Loaned by Japan Camera Inspection Institute,
 Tokyo

There was a preference in the Japanese market for 24 x 32 mm instead of the standard 24 x 36 mm format used by most manufacturers. This saved film, permitting an increased number of exposures on a roll of film. There was a number of professionals who advocated this format because it permitted enlargements to 8 x 10 without cropping. However, the reduced size was not continued because it was not compatible with automatic processing and printing machines used worldwide. The Minolta 35 was the first camera made in Japan to be fitted with a "hot-shoe" for flash photography.

Bolty 1947
Chiyoda Shokai Co., Ltd., Tokyo
L84:061:67
Loaned by Japan Camera Inspection Institute,
 Tokyo

The Bolty was a very early compact camera. It
used a special paperbacked rollfilm and made
twelve 24 x 24 mm exposures on a single roll.
Instead of the little red window normally used to
advance the film in simple cameras, the Bolty
employed an indexing system on the film advance
knob.

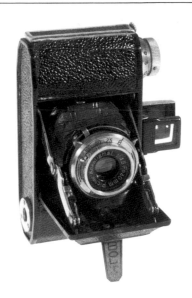

Minion 35 1948
Tokyo Optical Co., Ltd., Tokyo
L84:061:68
Loaned by Japan Camera Inspection Institute,
 Tokyo

The Minion was one of two compact 35mm fixed
lens cameras using 24 x 32 mm format to be mar-
keted in 1948 in Japan.

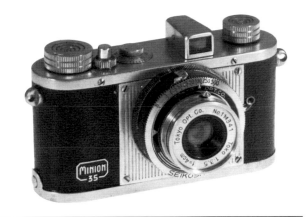

Petal 1948
Petal Kogaku Co., Tokyo
81:2297:32
International Museum of Photography at George
 Eastman House

The tiny Petal made six circular pictures on a
piece of round film just under an inch in diameter.
Each image was about ⅛th of an inch in diameter.
It is one of the smallest cameras ever mass pro-
duced in the world. A complete set of processing
accessories was available.

Mamiyaflex—Junior 1948
Mamiya Camera Co., Ltd., Tokyo
L84:061:69
Loaned by Japan Camera Inspection Institute,
 Tokyo

The Mamiyaflex Junior was a variant on standard
twin-lens reflex design. As on a few models made
by other manufacturers, the focusing system
employed an external gear arrangement that cou-
pled the taking and viewing lenses. This simple
system eliminated the need for more costly inter-
nal gears or cams and kept the price modest.

Olympus 35—Model 1 1948
Takachiho Optical Kogyo Co., Tokyo
L84:061:70
Loaned by Japan Camera Inspection Institute,
 Tokyo

Two relatively simple 35mm cameras with fixed
lenses for the Japanese standard 24 x 32 mm for-
mat appeared on the market in 1948. The Olym-
pus had a fully removable back and a self-cocking
shutter.

Nikon I 1948
Nippon Kogaku K.K., Tokyo
L84:006:1
Loaned by Nippon Kogaku, K.K., Tokyo

The Nikon Model I was a high quality product incorporating a number of advanced features. It had full lens interchangeability and a combined high and low shutter speed dial. Like the Minolta 35, it had a 24 x 32 mm format that could not be exported because of compatibility problems. The Allied Occupying Forces required that the format be changed to 24 x 36 mm to make it compatible with standard processing equipment. It was eventually succeeded by a model (the Nikon S-2) with a standard 24 x 36 mm format.

Mamiya 35 1948
Mamiya Camera Company, Ltd., Tokyo
L84:061:71
Loaned by Japan Camera Inspection Institute,
 Tokyo

This 35mm rangefinder camera, made during the reconstruction years of the industry, was the first to be equipped with a device that coupled the film advance mechanism to the shutter so that it would be cocked automatically when the film was advanced. An indicator, in the form of a red signal, appeared on a housing underneath the lens when the shutter had been cocked. The camera was focused by moving the film plane, one of the very few in general production to use this system. Since the shutter was rigidly mounted, it simplified the task of coupling the cocking mechanism to the camera.

Canon II-B 1949
Canon Camera Company, Inc., Tokyo
L84:061:72
Loaned by Japan Camera Inspection Institute,
 Tokyo

The general form of the Canon II-B, a 35mm rangefinder camera, was very similar to that of the Leica. However, the viewfinder was fitted with an optical arrangement so that it could be adjusted for three different focal length lenses. This was the first time this system was used on any camera in the world, and it eliminated the need for auxiliary finders normally needed with rangefinder cameras at the time. This original design patent was held by Canon.

Minolta 35—New Model 1949
Chiyoda Kogaku Seiko K.K., Osaka
L84:061:73
Loaned by Japan Camera Inspection Institute,
 Tokyo

The Minolta 35, made shortly after the war, used the Japanese standard 24 x 32 mm format when first introduced. Since this was not acceptable because it did not conform to international standards, Minolta, like all the other 35mm camera manufacturers, had to change over to the standard 24 x 36 mm format. This camera might be regarded as a transitional model. The 24 x 34 format of the New Model Minolta could be achieved without major retooling of the basic camera housing; but since it still did not conform to the world standard format, it was not produced in significant quantity.

Nikon M 1949
Nippon Kogaku, K.K., Tokyo
L84:006:2
Loaned by Nippon Kogaku K.K., Tokyo

This is the second model 35mm rangefinder camera made by Nippon Kogaku after the Second World War. Like the first model, it used a non-standard format. The format of the Nikon M was 24 x 34 mm. This is slightly larger than the first model, but still did not conform to the international standard. The Nikon M gained international fame during the Korean war when it was successfully used by many photographers under rugged combat conditions.

Mamiyaflex Automat—Model A 1949
Mamiya Camera Company, Ltd., Tokyo
L84:061:74
Loaned by Japan Camera Inspection Institute,
 Tokyo

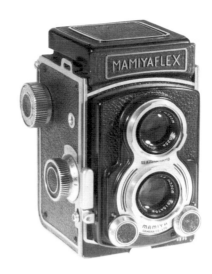

The Mamiyaflex Automat followed the traditional
design of twin-lens medium format cameras. The
loading system was the first in Japan and one of
the very few in the world that was nearly auto-
matic. The 120 film was inserted in the camera
and threaded to the takeup spool, and the camera
closed. It was not necessary to thread the film
through any sensing rollers or advance it to an
index mark. A gear system in the camera stopped
the film at the first frame when the advance knob
was turned.

Nicca—Model III 1949
Nippon Camera Co., Ltd., Tokyo
L84:061:75
Loaned by Japan Camera Inspection Institute,
 Tokyo

The Nicca was one of the highest quality of the
Leica copies made in Japan. A wide variety of
Nikkor lenses were available. Since the camera
was equipped with a standard Leica thread, any
Leitz lens could also be used. The viewfinder is
fitted with a diopter adjustment to correct for cer-
tain visual defects, the first time this was fitted to a
camera of Japanese manufacture.

Snappy 1949
Konishiroku Photo Industry Co., Ltd., Tokyo
L84:061:76
Loaned by Japan Camera Inspection Institute,
 Tokyo

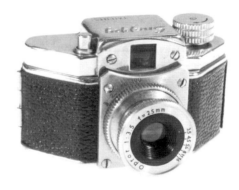

The subminiature Snappy, the shape of which sug-
gests a very tiny Exacta, used a special paper-
backed 16mm rollfilm. In addition to the standard
lens, a medium telephoto was available. The guil-
lotine shutter was a first in a camera of this type.

Fujica Six—Model 1-BS 1949
Fuji Photo Film Co., Ltd., Tokyo
L84:061:77
Loaned by Japan Camera Inspection Institute,
 Tokyo

At the time of its introduction in 1949, flash pho-
tography, using filament type flashbulbs, was very
popular. There were two basic electrical systems
employed to trigger the flashbulb. The more prim-
itive type was synchronized with a single contact
point. The circuit was completed by the flashgun
housing itself which was attached to the camera.
When this method was used, the flashgun could
not be moved away from the camera. Double con-
tact synchronizers were much more flexible and
allowed the flashgun to be positioned anywhere
the cord could reach. This was the first camera in
Japan to be fitted with this more advanced type of
synchronized shutter.

Minolta Memo 1949
Chiyoda Kogaku Seiko K.K., Osaka
L84:061:78
Loaned by Japan Camera Inspection Institute,
 Tokyo

The Minolta Memo was a full frame 35mm camera
of very simple design. The body is a single plastic
casting. A bottom mounted film advance and shut-
ter cocking mechanism was employed on this
model, unusual in an inexpensive camera and the
first of its type in Japan.

日本製カメラの変遷

**THE
EVOLUTION
OF THE
JAPANESE
CAMERA**

Yallu 1949
Yallu Optical Co., Ltd., Tokyo
L84:061:79
Loaned by Japan Camera Inspection Institute,
 Tokyo

The twin-lens reflex layout was generally limited
to the medium rollfilm format. Only a few were
madc for usc with 35mm film and the Yallu was
one of the two made in Japan of this design.

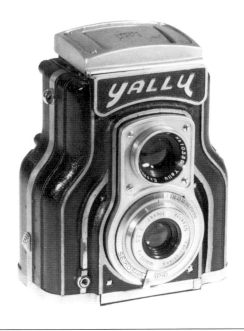

Look 1949
Look Camera Co., Ltd., Osaka
L84:061:80
Loaned by Japan Camera Inspection Institute,
 Tokyo

This straightforward 35mm fixed lens rangefinder
camera had an unusual film feed system. Instead
of a takeup reel, the exposed film was wound into
a second empty cassette. This eliminated the need
to rewind the film after finishing the roll. The
camera was fitted with a cutting blade to enable
the photographer to remove a portion of an
exposed roll of film.

Gem Flex 1949
Showa Optical Works, Ltd., Tokyo
L84:061:81
Loaned by Japan Camera Inspection Institute,
 Tokyo

The Gem Flex is a scaled down twin-lens reflex.
Paperbacked rollfilm and a very tiny red window
for advancing the film were used. Twelve
exposures, each 14 x 14 mm, were made on a
single roll.

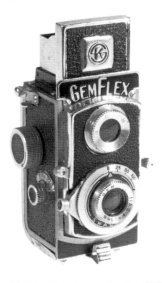

Cooky 35 1949
Kashiwa Seiko Co., Chiba
L84:061:82
Loaned by Japan Camera Inspection Institute,
 Tokyo

The very compact Cooky 35 used standard 35mm
cassettes and made 50 exposures, each 24 x 26
mm, on a roll. This was the only camera made in
the world to use this particular format.

Ricohflex—Model III 1950
Riken Optical Industries, Ltd., Tokyo
L84:061:83
Loaned by Japan Camera Inspection Institute,
 Tokyo

This very simple and inexpensive 120 rollfilm
twin-lens reflex camera was equipped with one of
the first flash synchronized shutters used on a
Japanese camera. A Kodak style flash post was
used for the first time in Japan.

Konan 16 Automat 1950
Chiyoda Kogaku Seiko K.K., Osaka
L84:061:84
Loaned by Japan Camera Inspection Institute,
 Tokyo

The film was advanced and the shutter cocked by a simple pull-push action on the Konan 16 Automat, the first time this system was used on a camera in Japan.

First Flex Camera Model P-1 1950
Tokiwa Seiki Co., Ltd., Tokyo
L84:061:85
Loaned by Japan Camera Inspection Institute,
 Tokyo

The popular twin-lens reflex design appeared in many variations in many countries. The First Flex was a very early Japanese version of this design and the first with a shutter with an X sync position for electronic flash.

Tanyflex 1950
Taniyama Camera Co., Ltd., Osaka
L84:061:86
Loaned by Japan Camera Inspection Institute,
 Tokyo

The Tanyflex is a medium-format 120 single-lens reflex rollfilm camera. An unusual feature was the built-in flashbulb holder. When not in use, it fitted flush with the camera body but could be slid into position for use by shifting it about 3 inches to the left. The camera body also housed the batteries for the flash. This is the first example of a camera of any format made in Japan with a completely integral flash system.

Teleca 1950
Toko Photo Co., Tokyo
L84:061:87
Loaned by Japan Camera Inspection Institute,
 Tokyo

The Teleca is a 16mm subminiature camera combined with a pair of binoculars that served as the viewfinder. The camera was fitted with a fixed telephoto lens.

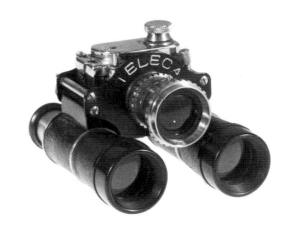

Mamiya 16 Super 1950
Mamiya Camera Company, Ltd., Osaka
77:750:1
International Museum of Photography at George
 Eastman House

The Mamiya 16 Super was a subminiature camera that used 16mm film contained in a special cassette. It was the first camera of Japanese manufacture with a built-in filter. A small lever on the camera would slide the filter into position. The filters were interchangeable and the photographer could select in advance which was needed.

Binox 1951
Binoca Co., Ltd., Tokyo
L84:061:88
Loaned by Japan Camera Inspection Institute,
 Tokyo

The very inexpensive plastic-bodied Binox was fitted with a feature normally found only on expensive professional cameras. It had a rotating back. The 4.5 x 6 cm film could be positioned for taking either horizontal or vertical format pictures.

日本製カメラの変遷

**THE
EVOLUTION
OF THE
JAPANESE
CAMERA**

Echo Eight 1951
Suzuki Optical Company, Ltd., Tokyo
L84:061:89
Loaned by Japan Camera Inspection Institute,
 Tokyo

This is a combination cigarette lighter and camera.
A subminiature camera is housed in the body of
the lighter. The little Echo Eight attained a degree
of fame when it was used by Audrey Hepburn
during a sequence in the film *Roman Holiday.*
The camera produces 6 x 6 mm images on one-
half of a section of 16mm film.

Tomic 1951
Toko Photo Co., Tokyo
L84:061:90
Loaned by Japan Camera Inspection Institute,
 Tokyo

The shutter blades in traditional leaf shutters are
of the reciprocating type. The blades open, come
to a complete stop, and then close. The maximum
speed possible with this type of shutter is gener-
ally not more than 1/250th of a second.
 The Tomic uses a four-bladed rotary shutter.
The elimination of the reciprocating components
made it possible to increase the maximum shutter
speed to 1/400th of a second. This was the first
use of this type of shutter on a camera of Japanese
manufacture.

Asahiflex—Model 1 1952
Asahi Optical Company, Ltd., Tokyo
81:1296:25
International Museum of Photography at George
 Eastman House
Gift of Asahi Optical Company

The first 35mm single-lens reflex camera to be
manufactured in Japan was the Asahiflex—
Model 1.

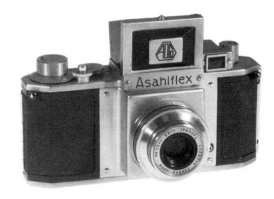

Olympus Chrome Six Camera—Model 3 1952
Olympus Optical Company, Ltd., Tokyo
L84:061:91
Loaned by Japan Camera Inspection Institute,
 Tokyo

All rollfilm cameras have to solve the problem of
maintaining film flatness. A unique spring system
that maintained tension, by stretching the film and
keeping it flat was a patented feature of the Olym-
pus Chrome Six. Normally it made 12 exposures
on a roll of 120 film. With a mask, it was capable
of making 16 exposures on a roll.

Koniflex 1952
Konishiroku Photo Industry Co., Ltd., Tokyo
L84:061:92
Loaned by Pentax Gallery, Tokyo

The automatic indexing system for advancing the
film without the need of visual number alignment
in a little red window was also a feature on the
Koniflex. The design is otherwise that of a stan-
dard twin-lens reflex.

Minoltaflex II-B 1952
Chiyoda Kogaku Seiko, K.K., Osaka
L84:061:93
Loaned by Japan Camera Inspection Institute,
 Tokyo

The Minoltaflex II-B also featured the automatic indexing film advance system that eliminated the need for lining up numbers in the little red window. The basic design of the camera was of the traditional twin-lens reflex type.

Airesflex—Model Z 1952
Aires Camera Works, Tokyo
L84:061:94
Loaned by Japan Camera Inspection Institute,
 Tokyo

The Airesflex—Model Z was one of the three medium format twin-lens reflex cameras introduced in the same month in 1952 of traditional design but incorporating, for the first time in Japan, the automatic indexing type of film advance system that eliminated the need for the little red window. The Airesflex was fitted with a Nikkor lens.

Pigeon 35 1952
Shinano Koki Company, Ltd., Suwa
L84:061:95
Loaned by Japan Camera Inspection Institute,
 Tokyo

This was the first camera to be manufactured in Japan with a thumb actuated winding lever that replaced the traditional winding knob. This type of film advance system was so clearly superior that it became standard throughout the industry. The Pigeon is a relatively simple fixed lens 35mm camera.

Nicca Camera—Model III-S 1952
Nicca Camera Co., Ltd., Tokyo
L84:061:96
Loaned by Japan Camera Inspection Institute,
 Tokyo

The rangefinder 35mm Leica manufactured in Wetzlar, Germany, was one of the most successful designs in the history of the photographic industry. This camera was closely copied by firms in the United States, Japan, England, France, Italy, and the Soviet Union. The list is probably longer. The Nicca was considered one of the best from Japan, and it was the first to be fitted with the German standard type of flash synchronization plug that was adopted by the entire industry. A variety of Nikkor lenses manufactured by Nippon Kogaku were available.

Panon 1952
Panon Camera Co., Tokyo
74:028:3055
International Museum of Photography at George
 Eastman House

The 120 rollfilm Panon was the first panoramic camera of Japanese manufacture for medium format photography. It is of the fixed, curved film plane, swinging lens variety. The shutter was cocked by moving the optical housing to one side. The image produced by the camera measured 43 x 115 mm.

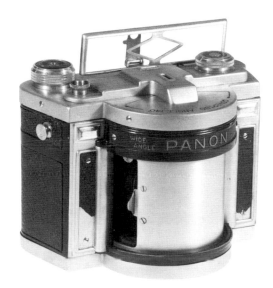

日本製カメラの変遷

THE
EVOLUTION
OF THE
JAPANESE
CAMERA

Arco 35 1952
Arco Photo Industry Co., Tokyo
L84:061:97
Loaned by Japan Camera Inspection Institute,
 Tokyo

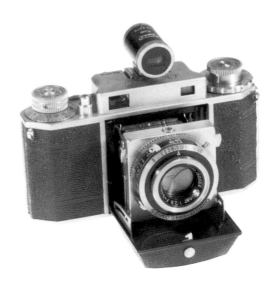

The optical/mechanical system of the Arco, a
35mm folding rangefinder camera, was designed
for very close focusing. By fitting a special finder
called the View Arco to the top of the camera and
coupling it to the lens for parallax correction, it
was possible to focus as close as 14 inches. The
special finder was equipped with an iris
diaphragm for previewing the depth-of-field, very
important in close-up photography. The film
counter indexed exposures from 36 to 0, the
reverse of the system used in most cameras. It was
the first time this type of reverse counting was
used on a Japanese camera.

Rich Ray 6 1952
Rich-Ray Shokai, Tokyo
L84:061:98
Loaned by Japan Camera Inspection Institute,
 Tokyo

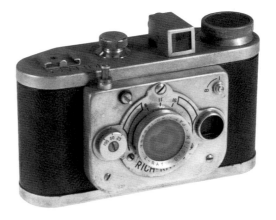

The appearance and general size of the Rich Ray 6
suggests that it is a 35mm camera. In reality, it is a
dual format 120 rollfilm camera for 4.5 x 6 or 6 x
6 cm photography. Built into the camera is a mir-
ror system that greatly reduces the size of the cam-
era by "folding" the light path. The actual taking
lens is to the right of what appears to be a cen-
trally mounted traditional lens. The maximum
thickness of the camera is about two inches, sig-
nificantly less than is normally required for a cam-
era of this format. The technical term for this
arrangement is the Z Optical Axis System. The
light path within the camera is in the form of the
letter Z.

Konilette—Model 1 1953
Konishiroku Photo Industry Co., Ltd., Tokyo
L84:061:99
Loaned by Japan Camera Inspection Institute,
 Tokyo

The very inexpensive Konilette was a compact
folding camera that used a special film and made
images of a unique format. Konishiroku manufac-
tured a special compact metal cassette that held
enough film for 12 exposures, each 30 x 36 mm.
It operated just like a regular 35mm cassette. After
exposure, the roll was rewound into the cassette
before unloading. A number of different models
of this camera were made, but the special film it
required limited the sales potential.

Richlet 1952
Rich-Ray Shokai, Tokyo
L84:061:100
Loaned by Japan Camera Inspection Institute,
 Tokyo

The little Richlet used a special paperbacked
sprocketless 35mm film. The image size was a
standard 24 x 36 mm. A small opening in back of
the camera could be used to store a spare roll of
film.

Canon IV Sb 1953
Canon Camera Company, Inc., Tokyo
L84:061:101
Loaned by Japan Camera Inspection Institute,
 Tokyo

The interchangeable lens 35mm Canon IV Sb was the first to be made in Japan equipped with a shutter capable of synchronizing with electronic flash units.

Mammy 1953
Mamiya Camera Company, Ltd., Tokyo
L84:061:102
Loaned by Japan Camera Inspection Institute,
 Tokyo

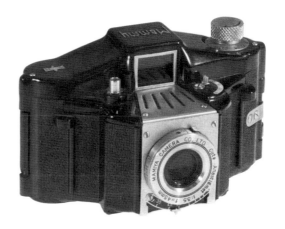

The very inexpensive plastic bodied Mammy used a special sprocketless 35mm paperbacked film. The focusing system was probably the first to indicate the distance, based on the zone focusing technique, in the viewfinder. A series of three colored filters automatically positioned themselves in the viewfinder as focus was changed. Red meant close, lack of color indicated the camera was set for the hyperfocal distance, and blue indicated distant objects. This simple camera is very important because it incorporates a very early example of information registration in a viewfinder.

Press Van 1953
Suzuki Optical Company, Ltd., Tokyo
L84:061:103
Loaned by Japan Camera Inspection Institute,
 Tokyo

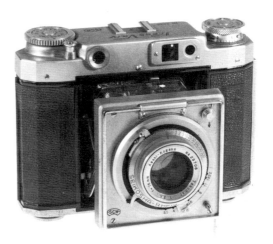

This medium format 120 rollfilm camera could, by inserting several reducing components and a special mask, be used with 35mm film. It was the first dual format camera of this type made in Japan and one of the few in the world. An indicator on the back of the camera switched the film counting mechanism from one format to the other.

Laurelflex 1953
Tokyo Optical Co., Ltd., Tokyo
L84:061:104
Loaned by Japan Camera Inspection Institute,
 Tokyo

This basic twin-lens medium format reflex camera was the first to be made in Japan that was fitted with a fresnel lens in the viewing screen. A fresnel lens might be described as a passive light amplifier and significantly brightens the image on a ground glass screen. It is used universally today.

Topcon 35 1953
Tokyo Optical Co., Ltd., Tokyo
L84:061:105
Loaned by Japan Camera Inspection Institute,
 Tokyo

The Topcon 35 was the first 35mm camera in Japan with a leaf type shutter and limited lens interchangeability. In addition to the 40mm standard lens, an 80mm medium telephoto lens was available. An accessory viewfinder was mounted on top of the camera when using the telephoto lens.

Windsor 1953
Toko Photo Co., Tokyo
L84:061:106
Loaned by Japan Camera Inspection Institute,
 Tokyo

With a 1 to 1 type of viewfinder it is possible to view a subject with both eyes open since the viewfinder system does not change the size of the scene being photographed. This is very desirable for some individuals. The Windsor, a modestly priced fixed lens 35mm camera, was the first Japanese camera with this feature.

Ricohflex Camera—Model VII 1953
Riken Kogaku Co., Ltd., Tokyo
L84:061:107
Loaned by Japan Camera Inspection Institute,
 Tokyo

The Ricohflex featured an unusual type of viewfinder in addition to the standard reflex finder. By viewing directly through the hood with both eyes open, one eye saw the complete scene, the other, the frame lines in the finder hood. The brain combined the two images outlining the taking area of the lens. An adapter for 35mm was available.

Lord 35 Model 1 1953
Okaya Optical Co., Ltd., Suwa
L84:061:108
Loaned by Japan Camera Inspection Institute,
 Tokyo

Two features appeared in a camera of Japanese manufacture for the first time on the Lord 35. On 35mm cameras using the world standard 35mm

cassette, it is necessary to rewind the film into the cassette after making the last exposure. To release the film for rewinding, it was usually necessary to depress *and* hold in the depressed position a button while rewinding. A mechanism on the Lord 35 locked the button into position simplifying the rewind process. Another feature was a knife blade which would cut the film, enabling the photographer to process a portion of a roll.

Asahiflex Model 1A 1953
Asahi Optical Company, Ltd., Tokyo
L84:061:109
Loaned by Japan Camera Inspection Institute,
 Tokyo

On any single-lens reflex camera, you normally must have the lens opened to its maximum aperture for viewing and focusing. Before taking a picture, it was necessary to stop the lens down to

whatever aperture was needed for correct exposure. As engineers strived to make the picture taking process less dependent on a series of decisions, means were devised to automate some of the steps. The Asahiflex Model 1A is an early example of a semi-automatic aperture control. After taking an exposure reading, the aperture was set. Then the lens could be opened for focusing and turned down to the pre-selected aperture without reference to the scale.

Stereo Alpen 1954
Hachiyo Kogaku Kogyo, Suwa
L84:061:110
Loaned by Japan Camera Inspection Institute,
 Tokyo

The Stereo Alpen was the first 35mm stereo camera to be made in Japan. It used the Stereo Realist format and made a pair of stereo images each 23 x 24mm. This format was used by nearly every modern 35mm camera made in the world.

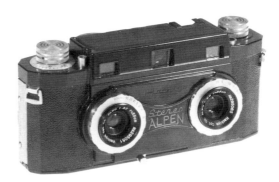

Riken 35 1954
Riken Optical Industries, Ltd., Tokyo
L84:061:111
Loaned by Japan Camera Inspection Institute,
 Tokyo

This fixed lens rangefinder type 35mm camera is fitted with a thumb actuated rapid film advance lever on the bottom of the camera in addition to the standard knurled top advance knob used on most cameras at the time. This is the first camera with this feature to be made in Japan.

Fujicaflex Automat 1954
Fuji Photo Film Co., Ltd., Tokyo
L84:061:112
Loaned by Japan Camera Inspection Institute,
 Tokyo

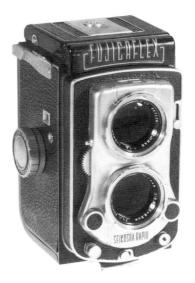

The Fujicaflex Automat was a premium twin-lens reflex camera for medium format photography. It incorporated a number of "firsts". A single knob mounted on the right side of the camera was used for film advance and focusing. The knob was left in the standard position for focusing and pulled out one notch to advance the film and cock the shutter. The lens had a special close focusing position. By depressing a button mounted next to the lens, a thumbwheel was released that enabled the photographer to focus as close as 2.3 feet without any accessory lenses. The shutter release could be set for either right or left handed persons.

Olympus 35 IV-a 1954
Olympus Optical Company, Ltd., Tokyo
L84:061:113
Loaned by Japan Camera Inspection Institute,
 Tokyo

This very early compact 35mm fixed lens camera was the first in Japan to be fitted with a glass pressure plate for precise maintenance of film flatness.

It appeared on the market at almost exactly the same time as a camera of German manufacture with a similar feature, a perfect example of simultaneous invention. Unfortunately, glass pressure plates are prone to accumulate static electricity charges which leave marks on the film, particularly during the dry winter months. The system had to be dropped in both Japan and Germany for the same reason.

Aram Six 1954
Aram Optical Co., Ltd., Tokyo
L84:061:114
Loaned by Japan Camera Inspection Institute,
 Tokyo

The Aram Six is a rangefinder equipped medium format folding camera with a self-erecting front. The focusing system is unusual and very carefully

engineered. Rotation of a remote thumbwheel mounted on back of the camera shifted the lens assembly to obtain correct focus. Other cameras equipped with thumbwheel remote focusing shifted the film in the focal plane. With this system, it was difficult to maintain film flatness. In the Aram Six, the film was held firmly in a fixed position between exposures eliminating this problem.

Doryu 2-16 1954
Doryu Camera Co., Tokyo
L84:061:115
Loaned by Japan Camera Inspection Institute,
 Tokyo

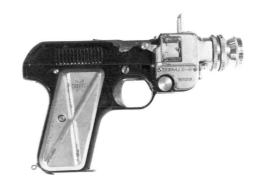

This 16mm subminiature camera is designed in the form of a hand pistol. The optics were of the standard C mount type used on most 16mm motion picture cameras. This meant that a very large variety of interchangeable lenses were available. The handgrip of the "pistol" housed a very unusual system for flash photography. Objects that closely resembled revolver cartridges contained flashpowder and an igniting chemical. When loaded, a striker fired the flash powder. It was advisable to keep the camera at arms length when using the flashgun to avoid severe facial burns.

日本製カメラの変遷

**THE
EVOLUTION
OF THE
JAPANESE
CAMERA**

Koniflex Model II 1954
Konishiroku Photo Industry Co., Ltd., Tokyo
L84:061:116
Loaned by Pentax Gallery, Tokyo

The Koniflex Model II was the first twin-lens reflex camera of Japanese manufacture with partial interchangeable lens capacity. The front element only could be changed to convert the lens to a medium telephoto focal length. A converter was also fitted to the viewing lens.

Aires 35 II 1954
Aires Camera Works, Tokyo
L84:061:117
Loaned by Japan Camera Inspection Institute,
 Tokyo

The Aires 35 II was the first camera made in Japan equipped with a bright-frame type of viewfinder. A bright-frame viewfinder incorporates a light gathering device which projects a frame in the viewfinder window that outlines the picture area covered by the lens. The instrument is of the fixed lens rangefinder type.

Asahiflex Model II-B 1954
Asahi Optical Company, Ltd., Tokyo
L84:061:118
Loaned by Japan Camera Inspection Institute,
 Tokyo

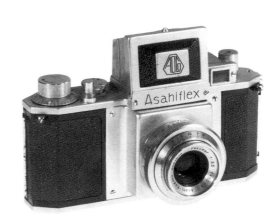

On all single-lens reflex cameras manufactured in the world until the Asahiflex II-B was announced, after making an exposure the viewfinder went black. The mirror, after raising up before the exposure was made, remained in this position until the shutter was re-cocked. This camera was fitted with the first instant-return mirror ever used on a production camera. This feature is of such importance that it became standard throughout the industry worldwide.

Firstflex 35 1954
Tokiwa Seiki Co., Ltd., Tokyo
L84:061:119
Loaned by Japan Camera Inspection Institute,
 Tokyo

The Firstflex was a waist-level 35mm single lens reflex camera with interchangeable lenses. The shutter was the leaf type instead of the more expensive curtain focal plane variety. It was the first of this type to be made in Japan and one of the earliest single-lens reflex instruments for this format.

Escaflex 1954
Esca Optical Co., Ltd., Tokyo
L84:061:120
Loaned by Japan Camera Inspection Institute,
 Tokyo

This medium format single-lens reflex camera is fitted with a between-the-lens leaf type shutter. The lenses were not interchangeable. This greatly simplified the camera and kept the price modest. It was the first in Japan of this type.

Nikon S-2 1954
Nippon Kogaku K.K., Tokyo
L84:006:4
International Museum of Photography at George
 Eastman House

This advanced version of the rangefinder Nikon was the first focal plane shutter camera with a linear shutter speed dial. Each successive step was exactly half the exposure time of the previous setting. This feature was so convenient that it soon became standard throughout the industry. A convenient folding rewind crank made its first appearance in Japan on this camera.

YashicaFlex S 1954
Yashima Optical Co., Ltd., Tokyo
L84:061:121
Loaned by Japan Camera Inspection Institute,
 Tokyo

The YashicaFlex S was the first twin-lens reflex
camera of Japanese manufacture with a built-in,
non-coupled selenium exposure meter. A scale
mounted on the top of the camera enabled the
user in this non-automated era to make exposure
calculations.

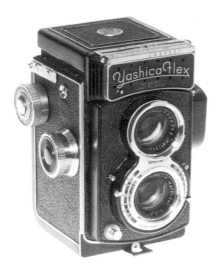

Stereo Rocca 1955
Rokawa Company, Ltd., Tokyo
L84:061:122
Loaned by Japan Camera Inspection Institute,
 Tokyo

The unusual Stereo Rocca made 24 stereo pairs,
each image measuring 23 x 24 mm, on standard
120 rollfilm. Unlike traditional stereo cameras
which imaged on alternate frames for the entire
length of the film, the Stereo Rocca stereo pairs
were made side-by-side on a standard 6 x 6 cm
120 frame. This somewhat limited the lens spac-
ing, but the stereo effect was still adequate. This
principle was adopted many years later by a cam-
era of Italian manufacture.

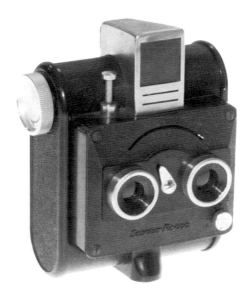

Stereo Hit 1955
Togodo Sangyo Co., Tokyo
L84:061:123
Loaned by Japan Camera Inspection Institute,
 Tokyo

The Stereo Hit was one of the earliest stereo cam-
eras to be manufactured by the reborn photo-
graphic industry after the Second World War and
the only one to use popular 127 rollfilm. It made
eight stereo pairs, each image measuring 30 x 40
mm, on a roll. There was also a provision for cap-
ping one lens and making 16 non-stereo pictures
on a roll.

Minoltacord Automat 1955
Chiyoda Kogaku Seiko K.K., Osaka
L84:061:124
Loaned by Japan Camera Inspection Institute,
 Tokyo

This otherwise traditional twin-lens reflex camera
had an engineering feature of great importance.
The takeup and feed spools were mounted in the
reverse of the position typical throughout the
industry. This permitted the tensioning of the film
over a longer distance and kept it considerably
flatter, vital for sharply focused images.

Pentaflex 1955
Tokiwa Seiki Co., Ltd., Tokyo
L84:061:125
Loaned by Pentax Gallery, Tokyo

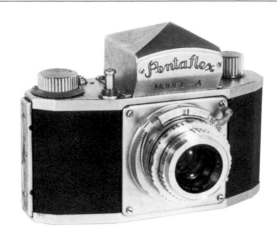

The Pentaflex was the first eye-level 35mm single-lens reflex camera of Japanese manufacture. A penta mirror, which performed essentially the same functions as a pentaprism, was employed in the viewing system. A penta mirror was considerably less costly to produce at the time than a pentaprism but had a number of disadvantages. The pentaprism system was refined and the cost reduced and it became an industry standard.

Minolta A 1955
Chiyoda Kogaku Seiko K.K., Osaka
L84:061:126
Loaned by Japan Camera Inspection Institute, Tokyo

Before cameras became automated, various methods were being tried out to simplify the process of making the adjustments needed to establish correct focus and exposure. The Minolta A, a fixed lens 35mm camera, was the first of Japanese manufacture to employ a linear, or equally spaced, aperture scale. This type of scale is not only easier to read but much more logical.

Neoca 35—Model 1-S 1955
Neoca Camera Industry, Ltd., Tokyo
L84:061:127
Loaned by Japan Camera Inspection Institute, Tokyo

The Neoca is an inexpensive fixed lens 35mm rangefinder camera for full frame photography. In order to keep the price as reasonable as possible,

the lens is of the front element focusing type. This is a very unusual design in a coupled rangefinder camera. Traditionally, when the entire lens focuses, a cam attached to the lens barrel activates the optics in the rangefinder to establish correct focus. To achieve this with a front element focusing lens, it was necessary to design a simple but effective method of coupling the front element to the rangefinder optics. This is the only camera ever manufactured using this system.

Primoflex V-A 1955
Tokyo Optical Company, Ltd., Tokyo
L84:061:128
Loaned by Japan Camera Inspection Institute, Tokyo

The Primoflex V-A was in most respects a standard twin-lens medium format camera but it had one feature that was unique. The upper or viewing

lens was fitted with an aperture control enabling the photographer to stop down the lens and preview the depth-of-field in various situations. Attachments were available for a number of cameras for this purpose, but this was the only one in the world with this feature built-in. Depth-of-field previewing devices have become standard on all quality cameras today.

Walz 35 1955
Walz Company, Ltd., Tokyo
L84:061:129
Loaned by Japan Camera Inspection Institute, Tokyo

The Walz 35 was the first camera made in Japan equipped with a shutter that could be adjusted for all three of the flash photography systems available at the time—electronic, filament flash, or gas filled bulb.

Miranda T 1955
Orion Camera Co. Ltd., Tokyo
L84:061:130
Loaned by Japan Camera Inspection Institute, Tokyo

The pentaprism type of viewfinder now used on all single-lens reflex cameras provides an erect, corrected right-left view of the scene being photographed. The first Japanese camera to incorporate this important feature was the Miranda T. The front mounted shutter release button coupled the semi-automatic aperture control in the lens to the camera body.

Olympus Wide 1955
Olympus Optical Company, Ltd., Tokyo
L84:061:131
Loaned by Japan Camera Inspection Institute,
 Tokyo

The fixed wide angle lens on this 35mm camera was the first fitted to a camera of this type. It is basically a simple camera which was scale-focused.

Minolta Autocord L 1955
Chiyoda Kogaku Seiko K.K., Osaka
L84:162:1
Loaned by Eastman Kodak
 Patent Department Museum,
 Rochester, New York

The Minolta Autocord L was a twin-lens reflex medium format camera of generally traditional design, but it was fitted with a non-coupled exposure meter that made light readings in the LV, or light-value, system. A single reading from the meter was transferred to the shutter and aperture control dials. This was a somewhat simplified method of establishing an over-all exposure. The Minolta Autocord L was the first Japanese camera of this type fitted with an LV meter.

Lord 35 IV B 1955
Okaya Optical Company, Ltd., Suwa
L84:061:132
Loaned by Japan Camera Inspection Institute,
 Tokyo

The compact 35mm Lord 35 was fitted with a very desirable convenience feature. The process of rewinding the film after exposure was greatly simplified and speeded up by a rewinding system that converted the knob to a small crank. Fast action crank rewinders are standard on all 35mm cameras today.

Mamiya Six Automat 1955
Mamiya Camera Company, Ltd., Tokyo
L84:061:133
Loaned by Japan Camera Inspection Institute,
 Tokyo

The medium format Mamiya Six is a folding roll-film camera with a self-erecting optical system. On all other cameras of this type, the shutter must be manually cocked in a separate action. On the Mamiya Six, this is done automatically at the same time the film is advanced, the first in the world with this feature. A focusing system devised by Mamiya simplified the use of the camera. A thumbwheel on the back of the body racked the lens in and out. This feature was used on other Mamiya models.

Hofman Camera 1955
Hofman Camera Co., Ltd., Kyoto
L84:061:134
Loaned by Japan Camera Inspection Institute,
 Tokyo

At the time of its introduction, the 3 ¼ x 4 ¼ inch format was very popular with press photographers. The Hofman was the first press type camera of Japanese manufacture to use this format.

Ricohflex Dia 1956
Riken Optical Industries, Ltd., Tokyo
L84:061:135
Loaned by Japan Camera Inspection Institute,
 Tokyo

In 1956, the twin-lens reflex was the most popular type of medium format camera on the market, and a very large number of models were available from many manufacturers. The focusing system most generally used was a cam actuated by a knob mounted on the side of the camera. The Ricohflex Dia has two levers mounted on each side of the body next to the optical system. By raising or lowering either lever, the lens could be focused. The design was ideally suited for left or right hand operation.

Topcon 35 S 1956
Tokyo Optical Company, Ltd., Tokyo
L84:061:136
Loaned by Japan Camera Inspection Institute,
 Tokyo

The Topcon 35 S is a standard 35mm rangefinder camera with fixed optics. The viewfinder is of the "life-size" or 1 to 1 type. A relatively complicated optical system is used to provide a viewfinder with unusual clarity. Extremely good, bright viewfinders are one of the most desirable features cited by many camera users. The rewind knob on this model has two positions. It can be raised for easier gripping when rewinding the film.

Konica II-A 1956
Konishiroku Photo Industry Co., Ltd., Tokyo
L84:061:137
Loaned by Japan Camera Inspection Institute,
 Tokyo

Flash synchronized shutters must be adjusted so that they open during the brightest portion of the flash. When the Konica II-A was marketed in 1956, there were three types of flash systems available, filament filled bulb, gas-filled bulb, and electronic, each having special synchronization requirements. Most shutters had settings to adjust the delay depending on the flash system used, but even with the proper setting, the matching of the flash and shutter was never exact. The Konica II-A was fitted with a shutter of special design that could match nearly perfectly the shutter opening with the peak of the flash burn. This was the first time this very sophisticated device was fitted to any camera.

Konica III 1956
Konishiroku Photo Industry Co., Ltd., Tokyo
L84:061:138
Loaned by Japan Camera Inspection Institute,
 Tokyo

The Konica III was fitted with a lever on the front of the camera that surrounded the lens/shutter assembly for advancing the film and cocking the shutter. This was the first camera of Japanese manufacture fitted with this variation on film advance systems.

Mamiyaflex C Professional 1956
Mamiya Camera Company, Ltd., Tokyo
L84:061:139
Loaned by Japan Camera Inspection Institute,
 Tokyo

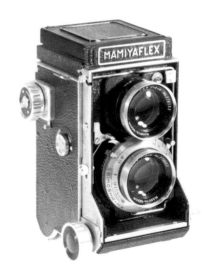

THE EVOLUTION OF THE JAPANESE CAMERA

The Mamiyaflex interchangeable twin-lens reflex camera for medium format 120 film was the first to be produced in Japan of this type and certainly one of the most successful camera designs ever marketed. More than a quarter of a century after the original model was introduced, the basic camera is still in production. Recent models have a number of refinements, but the basic design remains intact. It is rugged, durable and a great favorite of many professional photographers.

Rittreck 1956
Musashino Koki K.K., Kawasaki
L84:061:140
Loaned by Japan Camera Inspection Institute,
Tokyo

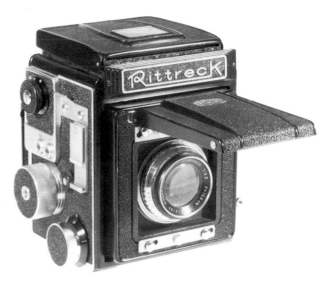

The medium format Rittreck had both inter-
changeable backs and lenses. Eight 6 x 9 cm
exposures could be made on a roll of 120 film. A
dark slide permitted films to be changed in
"midstream" without the loss of an exposure. The
focal plane shutter permitted the use of a variety
of interchangeable lenses making it a very versatile
instrument. It was the first to be produced in
Japan of this type.

Mamiya Magazine 35 1957
Mamiya Camera Company, Ltd., Tokyo
74:028:3120
International Museum of Photography at George
Eastman House

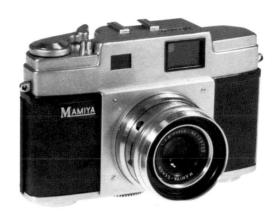

The ability to interchange backs on 35mm cam-
eras enabling the photographer to change from
one emulsion type to another without having to
finish a film has been tried on production cameras
very few times. The Ektra introduced by the East-
man Kodak Company before the Second World
War had this system, but production ceased in
1948 and was never revived. The Mamiya
organization marketed its version of an inter-
changeable back camera in 1957, the second of its
type in the world.

Minolta Auto Wide 1957
Chiyoda Kogaku Seiko K.K., Osaka
L84:061:141
Loaned by Japan Camera Inspection Institute,
Tokyo

The Minolta Auto Wide, introduced in the same
year as the Mamiya Elca, shares the honor of being
one of the first cameras in Japan with an integral

semi-automatic exposure system. Like the Mamiya,
the interlocked aperture and shutter speed con-
trols were adjusted until two needles matched,
indicating correct exposure. Since these cameras
were introduced the same year with this impor-
tant feature, it was determined to include them
both in the exhibit.

Mamiya Elca 1957
Mamiya Camera Company, Ltd., Tokyo
L84:061:142
Loaned by Japan Camera Inspection Institute,
Tokyo

The Mamiya Elca was the first camera in Japan to
be equipped with an integral semi-automatic
exposure control system of the match needle
type. The aperture and shutter speed controls
were interlocked and one or the other could be
turned until two needles in a small window on top
of the camera lined up, setting the camera for the
correct exposure. The lens and meter were cou-
pled electronically, a first in the industry. It was
also the first camera with a linear shutter speed
dial, where each increase in speed was an exact
doubling of the previous setting.

No single camera design has had a greater impact on serious photographers than the 35mm single-lens reflex. The first instruments to use this design principle appeared in Germany in the middle 1930s. The small ground-glass waist-level viewers made them difficult to use and they never enjoyed widespread popularity. Shortly after the Second World War, the original Zeiss organization in Jena, in what is now East Germany, produced a new model called the Contax S. It was the first camera to use an optical-viewing system with a penta-prism. Relatively few were made and their quality was indifferent. This is a five-sided glass solid, mirrored on the appropriate surfaces, that enables the user to view the image from a ground glass in proper perspective at eye level. The potential and advantages of this system were quickly recognized in Japan. The Nikon F, introduced by Nippon Kogaku in 1955, was a finely crafted instrument that was to become world reknowned for its excellence and the camera of choice of many professionals and advanced amateurs. This model Nikon was the core of what would quickly become the first extensive 35mm single-lens reflex system. All these cameras are representative of the new wave of 35mm SLR technology, and each was the first to employ an important new design innovation that generally became standard throughout the rapidly growing industry.

**THE
EVOLUTION
OF THE
JAPANESE
CAMERA**

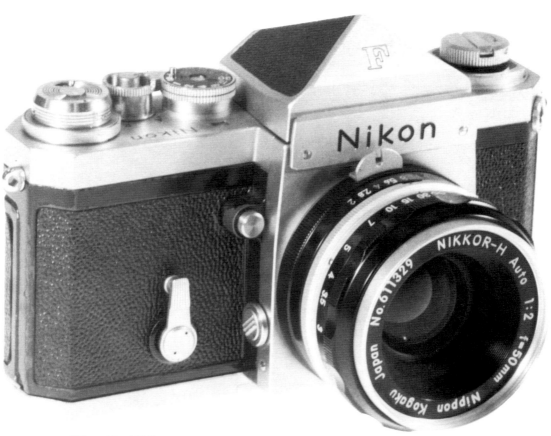

Nikon F 1959
See checklist page 58

Miranda T 1955
See checklist page 48

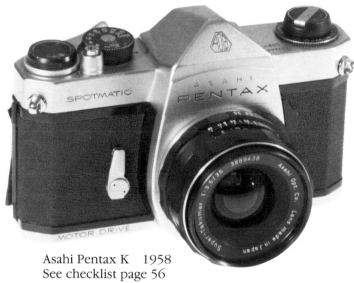

Asahi Pentax K 1958
See checklist page 56

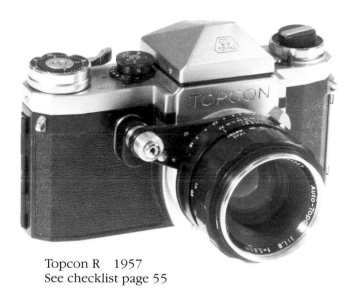

Topcon R 1957
See checklist page 55

THE EVOLUTION OF THE JAPANESE CAMERA

Minolta Super A 1957
Chiyoda Kogaku Seiko K.K., Osaka
L84:061:143
Loaned by Japan Camera Inspection Institute,
 Tokyo

This interchangeable lens 35mm rangefinder camera was the first to be made in Japan with an accessory light meter that coupled to the shutter speed setting dial for limited automatic exposure control.

Fish Eye Camera 1957
Nippon Kogaku K.K., Tokyo
L84:061:144
Loaned by Japan Camera Inspection Institute,
 Tokyo

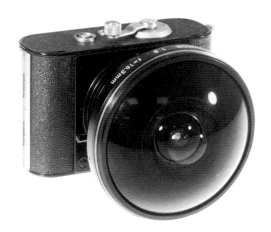

The Hill Cloud Camera made in Great Britain in 1925 was the first production camera to use what we now call a fish-eye lens. A lens of this type will generally cover a circular field of 180°. There is no effort made to correct for any spherical distortion. The Nikon Fish-Eye Camera which made an image about 2 inches in diameter on a frame of 120 rollfilm was the first production camera in the post-war era to be fitted with a lens of this type. It was actually designed for the same purpose as the original Hill camera, the observation of cloud formations by the weather bureau. In more recent years, fish-eye lenses have become generally available as accessory optics for a number of cameras and are used for creative special effects.

Minolta 16 1957
Chiyoda Kogaku Seiko K.K., Osaka
L84:061:145
Loaned by Japan Camera Inspection Institute,
 Tokyo

The Minolta 16 was the first subminiature camera of Japanese manufacture with a mechanism that advanced the film and cocked the shutter automatically when the camera was opened and closed. The 16mm film used by the camera was carried in special cassettes. One of the Soviet camera manufacturing firms made a copy of this camera that is so exact that many of the parts are actually interchangeable.

Fujipet 1957
Fuji Photo Film Co., Ltd., Tokyo
L84:061:146
Loaned by Japan Camera Inspection Institute,
 Tokyo

The Fujipet was a simple type of 120 rollfilm camera with a very limited range of adjustments. The built-in sliding sunshade was a first for a camera of this type.

Fujica 35M 1957
Fuji Photo Film Co., Ltd., Tokyo
L84:061:147
Loaned by Japan Camera Inspection Institute,
 Tokyo

The Fujica 35M is a very inexpensive type of 35mm full frame rangefinder camera. Instead of the usual helical focusing gear, the lens is mounted in a double tube. It was focused by sliding one tube inside of the other using a very simple gear train. This system was considerably less costly than the traditional methods but worked effectively. The side mounted rewind knob was a first for any camera and saved a considerable amount of space on top of the camera, making it more compact.

Nikon SP 1957
Nippon Kogaku K.K., Tokyo
L84:006:5
Loaned by Nippon Kogaku K.K., Tokyo

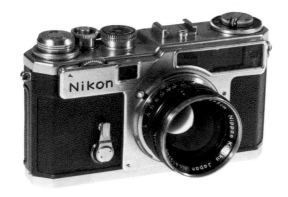

The Nikon SP was one of the most refined versions of this style of rangefinder 35mm camera manufactured by Nippon Kogaku. The shutter speed dial combined both slow and fast speeds, and the viewfinder framed automatically and previewed 50, 85, 105, and 135mm lenses. A separate section in the viewfinder window was for use with 28 and 35mm lenses. The Nikon SP framed more accessory lenses than any other camera of this type made by any manufacturer.

Topcon R 1957
Tokyo Optical Company, Ltd., Tokyo
L84:061:148
Loaned by Japan Camera Inspection Institute, Tokyo

The Topcon R was the first 35mm single-lens reflex of Japanese manufacture to be fitted with a pre-set diaphragm. The photographer viewed and focused at full aperture. When the shutter was released, it stopped down to a pre-determined setting before the exposure was made. The Topcon also incorporated a split image focusing system within the pentaprism finder.

Canon VL 1958
Canon Camera Company, Inc., Tokyo
L84:061:149
Loaned by Japan Camera Inspection Institute, Tokyo

The focal plane shutter in the Canon VL was the first to be made in Japan using metal instead of cloth. An extremely thin piece of black anodized aluminum replaced the rubberized fabric used in most cameras. One of the advantages of a metal shutter is that it cannot be accidentally damaged by sunlight when left unattended with the lens cap removed.

Minolta V-2 1958
Chiyoda Kogaku Seiko K.K., Osaka
L84:061:150
Loaned by Japan Camera Inspection Institute, Tokyo

The 1/2000th of a second shutter speed on the Minolta V-2 was the fastest, at the time, on a fixed lens 35mm camera made by any manufacturer in the world. There was one limitation. When used at maximum speed, the widest usable aperture was f/8, which meant that the subject had to be brightly lit and a fast film was required.

Zunow 1958
Zunow Optical Industries, Tokyo
L84:061:151
Loaned by Japan Camera Inspection Institute, Tokyo

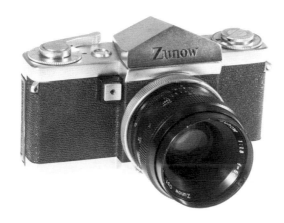

The Zunow was the first Japanese made single-lens reflex camera fitted with an automatic pre-set aperture control. This important feature permitted focusing and viewing at full aperture for maximum brightness and then automatically stopped down to a pre-determined setting before the picture was taken. It is a standard feature of all cameras of this type today.

日本製カメラの変遷

Miranda B 1958
Miranda Camera Company, Ltd., Tokyo
L84:061:152
Loaned by Japan Camera Inspection Institute,
 Tokyo

On the Miranda B, depressing the front mounted shutter release button sets the aperture to a pre-determined position. This form of semi-automatic aperture control first appeared on this camera.

Konica III-A 1958
Konishiroku Photo Industry Co., Ltd., Tokyo
L84:061:153
Loaned by Japan Camera Inspection Institute,
 Tokyo

The rangefinder/viewing system in the Konica III-A is very sophisticated. The fixed lens on the camera has a close-focusing position which requires a great deal of parallax compensation in the viewfinder. In most cameras, this is achieved by shifting the image position slightly. However, in the Konica III-A, the actual shift is recorded with great accuracy in all dimensions. This is the only time this very expensive system was used in a production camera.

Yashica 44 1958
Yashima Kogaku Kogyo, Tokyo
L84:061:154
Loaned by Japan Camera Inspection Institute,
 Tokyo

The Yashica 44 twin-lens 4 x 4 cm reflex was a traditional design fitted with an f/3.5 taking lens mounted in a Copal shutter. Both the Yashica 44 and the Primo Jr. were the first of this design and format to be made in Japan.

Primo Jr. 1958
Tokyo Optical Company, Ltd., Tokyo
L84:061:155
Loaned by Japan Camera Inspection Institute,
 Tokyo

In the same month in 1958 the Tokyo Optical Company, Ltd. and Yashima Kogaku Kogyo, now the Yashica Company, introduced very similar 4 x 4 cm twin-lens reflex cameras. The Tokyo Optical Company version was fitted with an f/2.8 taking lens mounted in a Seikosha shutter.

Asahi Pentax K 1958
Asahi Optical Company, Ltd., Tokyo
L84:061:156
Loaned by Japan Camera Inspection Institute,
 Tokyo

The focusing screen in the Asahi Pentax K was the first of the micro prism type. For many individuals

it is difficult to focus accurately on a ground glass screen, particularly if they have some visual defect. A micro prism is a very fine series of rulings which appear to shimmer when not in correct focus. The development of this system was a very important step in the improvement of single-lens reflex camera design.

Minolta SR-2 1958
Chiyoda Kogaku Seiko K.K., Osaka
L84:061:157
Loaned by Japan Camera Inspection Institute,
 Tokyo

All 35mm single-lens reflex cameras manufactured today are fitted with automatic diaphragms which allow you to focus at full aperture. They stop down automatically to the correct aperture before the picture is taken. The first camera to have this feature in Japan was the Minolta SR-2. The diaphragm was coupled to the film advance mechanism. When the film was advanced, it opened to full aperture for the brightest possible viewing and focusing and automatically stopped down. It was also the first camera fitted with multi-coated optics which significantly reduce lens flare.

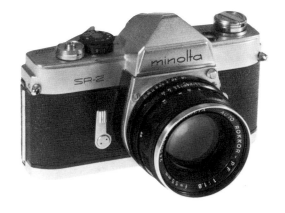

Aires 35 V 1958
Aires Camera Industry Company, Ltd., Tokyo
L84:061:158
Loaned by Japan Camera Inspection Institute,
 Tokyo

The optics on the Aires 35 V rangefinder camera were interchangeable. It was fitted with a leaf shutter and had the fastest lens (f/1.5) available on a camera of this type.

Panorax ZI-A 1958
Nippon Tokushukoki Co., Kawasaki
L84:061:159
Loaned by Japan Camera Inspection Institute,
 Tokyo

The Panorax ZI-A is a panoramic camera of unique design. Film from a standard 35mm cassette is positioned in a circle inside the camera. A clockworks mechanism rotates the optical system in a circle that measures just under 360 degrees creating a panoramic image. An external mirror directs the image forming light outside the camera through the optical system, and another mirror inside the camera redirects the focused image onto the film. It is the only panoramic camera in the world to use a rotating mirror/optical system. Only a handful of these very unusual cameras were made.

Kallo T 1959
Kowa Company, Ltd., Nagoya
L84:061:160
Loaned by Japan Camera Inspection Institute,
 Tokyo

A fixed medium 100mm telephoto lens was fitted to the Kallo T. A focal length in this range was most useful for portraiture and the camera was probably intended primarily for that purpose. It could, of course, have been used in a variety of other photographic situations.

Konica III-M 1959
Konishiroku Photo Industry Co., Ltd., Tokyo
L84:061:161
Loaned by Japan Camera Inspection Institute,
 Tokyo

The Konica III-M was the first camera of Japanese manufacture, and one of the few in the world, with dual-format capability. The photographers had a choice before inserting the film of either full or half frame 35mm photography. A mask could be manually inserted if the smaller half frame format was desired.

Mamiya Sketch 1959
Mamiya Camera Company, Ltd., Tokyo
L84:061:162
Loaned by Japan Camera Inspection Institute,
 Tokyo

In addition to the standard 24 x 36 mm full frame and 18 x 24 mm half frame formats, there was a third format introduced before the Second World War in Germany by the Robot Company. The "Robot" format was a square 24 x 24 mm image. The Mamiya Sketch was the first camera to be made in Japan for this rather specialized size.

Yashica Y-16 1959
Yashica Company, Ltd., Suwa
L84:061:163
Loaned by Japan Camera Inspection Institute,
 Tokyo

The Yashica Y-16 was a subminiature camera using 16mm film contained in a pre-loaded cartridge. It was a relatively early example of a well-made subminiature camera of Japanese manufacture.

日本製カメラの変遷

Nikon F 1959
Nippon Kogaku K.K., Tokyo
L84:006:6
Loaned by Nippon Kogaku K.K., Tokyo

The Nikon F was the first completely professional single-lens reflex camera made in the world. It incorporated a number of basic features essential to the professional, such as interchangeable focus-

ing screens, mirror lock-up, and very precise mechanics. The camera became the center piece of the first complete single-lens reflex system. Eventually, lenses ranging from 6mm fish-eye through 2000mm telephoto optics became available. The basic camera remained in production with only slight changes for nearly 14 years, a testimony to its sound design.

Zenza Bronica 1959
Bronica Company, Ltd., Tokyo
L84:061:164
Loaned by Japan Camera Inspection Institute, Tokyo

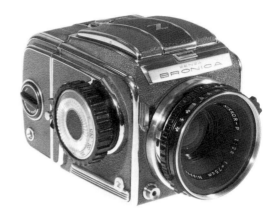

The Zenza Bronica was the first of the 6 x 6 cm single-lens reflex cameras with full lens and back interchangeability manufactured in Japan. The original models were fitted with Nikkor lenses made for the Zenza organization. It incorporated a number of unusual design features, such as a mirror that permitted the use of lenses of any focal length and a combined film advance and shutter cocking knob.

Widelux 1959
Panon Camera Shoko Company, Ltd., Tokyo
78:914:1
International Museum of Photography at George Eastman House
Gift of the Panon Camera Company

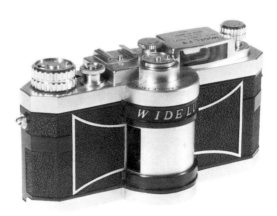

The Widelux was the first 35mm panoramic camera of the fixed film plane/moving lens type that was ever made for general sale. The film in a standard 35mm cassette is held in a curved focal plane. Either eleven 24 x 58 mm exposures on a standard 20 exposure or 21 on a 36 exposure roll may be made. The lens covers a field of 140° horizontally and 55° vertically, virtually the same as that of the human eye.

Kallo 180 1959
Kowa Company, Ltd., Nagoya
L84:061:165
Loaned by Japan Camera Inspection Institute, Tokyo

Until 1971, the standard 35mm cassette that had been in use for decades was designed, when mounted in a typical left-feed position, to be rewound with a lever that engaged a bar built into the cassette. This required that the rewind lever be top mounted. In order to allow more room for the rangefinder/viewfinder system, the Kowa Company designed a camera with a bottom mounted rewind knob that employed an unusual mechanism that gripped the film spool eliminating the need for a built-in bar. After 1971, the cassettes were manufactured with bars built into both ends to enable manufacturers to design cameras with either top or bottom mounted rewind systems not requiring special devices.

Septon Pen 1959
Okamoto Optical Co., Ltd., Tokyo
L84:061:166
Loaned by Japan Camera Inspection Institute,
 Tokyo

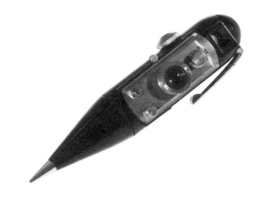

The Septon Pen is a combination subminiature
camera and automatic pencil. Housed in the plas-
tic body is a camera that made ten 12 x 13 mm
exposures on a special film. It is the only true
combination of an actual writing instrument and
camera ever produced.

Ramera 1959
Kowa Company, Ltd., Nagoya
L84:061:167
Loaned by Japan Camera Inspection Institute,
 Tokyo

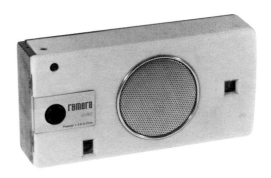

The Ramera is a combination radio and camera,
thus the name Ramera. A simple 16mm camera is
built into the radio body. A pull knob on the bot-
tom of the instrument advances the film and cocks
the shutter. The other controls are mounted on
the side. This was the first time a compact transis-
tor radio and camera were combined in a single
housing.

Kowa 140 1959
Kowa Company, Ltd., Nagoya
L84:061:168
Loaned by Japan Camera Inspection Institute,
 Tokyo

The f/1.4 standard lens was the fastest available on
a camera of Japanese manufacture at the time of its
production. The Kowa 140 is a 35mm camera of
the coupled rangefinder type with interchangeable
lenses.

Olympus Pen 1959
Olympus Optical Company, Ltd., Tokyo
L84:061:169
Loaned by Japan Camera Inspection Institute,
 Tokyo

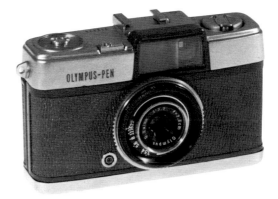

The standard format for 35mm still photography
is 24 x 36 mm. Over the years a number of cam-
eras have been produced for the so-called half
frame format which produced an image exactly
half the size or 18 x 24 mm. This format doubled
the number of exposures it was possible to make
on a single roll of film. The Olympus Pen was the
first camera manufactured in Japan for this format.
It was also the first camera to use a thumb actu-
ated film advance mounted on the rear of the
camera.

Ricohmatic 44 1959
Riken Optical Industries, Ltd., Tokyo
L84:061:170
Loaned by Japan Camera Inspection Institute,
 Tokyo

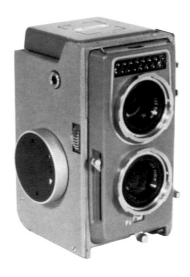

The Ricohmatic 44 was a twin-lens reflex camera
capable of making twelve 4 x 4 cm exposures on a
roll of 127 film. The semi-automatic exposure sys-
tem on the camera is somewhat unusual. The
shutter speed control was coupled to the ASA film
speed dial. By setting the camera for the proper
ASA, the user selected a shutter speed. The aper-
ture was then set by matching a needle visible in a
window on top of the camera.

日本製カメラの変遷

THE
EVOLUTION
OF THE
JAPANESE
CAMERA

Lord Martian 1960
Okaya Optical Co., Ltd., Nagano
L84:061:171
Loaned by Japan Camera Inspection Institute,
 Tokyo

The traditional place for mounting the cluster of
selenium photocells in early camera designs with
built-in meters was on a portion of the camera
body. On the Lord Martian, the cells are arranged
in a ring around the lens. This significantly more
efficient arrangement resulted in a large photocell
area without the need to increase the camera size.

Aires Viscount M-2.8 1960
Aires Camera Industry Company, Ltd., Tokyo
L84:061:172
Loaned by Japan Camera Inspection Institute,
 Tokyo

The semi-automatic exposure meter, which is an
integral part of the Aires Viscount, displays the
exposure information in the viewfinder. This fea-
ture, which was eventually adapted by the entire
industry in some form, first appeared on a camera
of Japanese manufacture with this model.

Nikkorex 35 1960
Nippon Kogaku K.K., Tokyo
L84:006:8
Loaned by Nippon Kogaku K.K., Tokyo

The pentaprism used in 35mm single-lens reflex
cameras is relatively heavy and expensive to man-
ufacture. In order to produce an inexpensive
single-lens reflex with most of the advantages of
the pentaprism type of camera, Nippon Kogaku
designed the Nikkorex 35. Instead of a solid glass
pentaprism, a mirror system erects and reverses
the image.

Konica F 1960
Konishiroku Photo Industry Co., Ltd., Tokyo
L84:061:173
Loaned by Japan Camera Inspection Institute,
 Tokyo

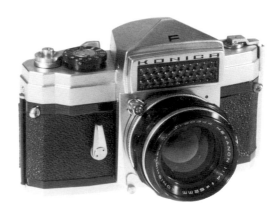

The Konica F was fitted with the fastest (1/2000th
of a second) shutter available on a single-lens
reflex at the time. It was also the first metal blade
focal plane shutter manufactured in the world.
Exposure control was of the semi-automatic type
with an external selenium type photocell.

Minolta Uniomat 1960
Minolta Camera Company, Ltd., Osaka
L84:061:174
Loaned by Japan Camera Inspection Institute,
 Tokyo

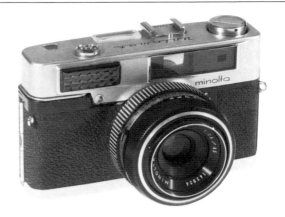

The aperture control and shutter blades of the
fixed lens Minolta Uniomat are combined. This
system originated in the United States on a shutter
designed by Bausch & Lomb around the turn of
the century. It is the only time this idea was ever
used on a 35mm camera.

Polaroid Land 120 1960
Yashica Company, Ltd., Suwa
L84:061:175
Loaned by Japan Camera Inspection Institute,
 Tokyo

The Polaroid Corporation of Cambridge, Massa-
chusetts, began marketing the world's first instant
photographic process in 1948. The original Land
cameras were made in the U.S. Toward the end of
the 1950s, Polaroid contracted with the Yashica
Company to manufacture a camera to their specifi-
cations to use Polaroid film. It was the first camera
for instant photography manufactured in Japan.

Olympus Auto Eye 1960
Olympus Optical Company, Ltd., Tokyo
L84:061:176
Loaned by Japan Camera Inspection Institute,
 Tokyo

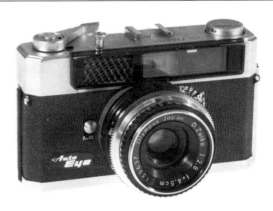

The Olympus Auto Eye was the first fixed lens
35mm camera of Japanese manufacture with an
automatic exposure control system of the shutter
speed priority type. The user selected a desired
shutter speed, and the metering system set the
aperture.

Aires Radar Eye 1960
Aires Camera Industry Company, Ltd., Tokyo
L84:061:177
Loaned by Japan Camera Inspection Institute,
 Tokyo

The 1/1000th of a second maximum speed of the
between-the-lens leaf shutter fitted to the Aires
Radar Eye was the fastest manufactured by any
company. The camera was of the 35mm coupled
rangefinder type with a built-in semi-automatic
exposure system.

Minolta V-3 1960
Minolta Camera Company, Ltd., Osaka
L84:061:178
Loaned by Japan Camera Inspection Institute,
 Tokyo

The Minolta V-3 was a rangefinder type 35mm
camera with an unusual shutter. The leaf shutter
had a maximum speed of 1/3000th of a second
making it the fastest of its type in the world, how-
ever, there was one limitation. When used at the
top speed, the shutter opened only partially
resulting in a maximum effective aperture of f/8.
This limited the use of the camera, when used at
that speed, to brightly lit situations.

Miranda Automex 1960
Miranda Camera Company, Ltd., Tokyo
L84:061:179
Loaned by Japan Camera Inspection Institute,
 Tokyo

The external selenium type exposure meter on the
Miranda Automex was mechanically coupled to
the lens. It was the first Japanese camera to offer
this feature.

Topcon Wink Mirror 1960
Tokyo Optical Company, Tokyo
L84:061:180
Loaned by Japan Camera Inspection Institute,
 Tokyo

The Topcon Wink Mirror featured an instant return mirror in conjunction with a leaf type between-the-lens shutter. It was the first camera to achieve this combination.

Yashica Rapid 1961
Yashica Company, Ltd., Suwa
L84:061:181
Loaned by Japan Camera Inspection Institute,
 Tokyo

Thc Yashica Rapid was a half frame 35mm camera of somewhat unusual design. Pulling a leather strap attached to the bottom of the camera advanced the film and cocked the shutter. An exposure meter was built into the camera but not coupled.

Canonet 1961
Canon Camera Company, Inc., Tokyo
L84:061:182
Loaned by Japan Camera Inspection Institute,
 Tokyo

The automatic exposure control on the Canonet had a safety device that locked the shutter release and prevented a picture from being taken if the light level was too low.

Fujipet EE 1961
Fuji Photo Film Co., Ltd., Tokyo
L84:061:183
Loaned by Japan Camera Inspection Institute,
 Tokyo

The Fujipet EE is a very simple medium format camera for twelve 6 x 6 cm exposures on 120 rollfilm. A very simple type of automatic exposure control varied the aperture. The shutter speed was fixed.

Viscawide-16 1961
Taiyo Kogyo Kabushiki Kaisha, Tokyo
78:930:1
International Museum of Photography at George
 Eastman House

There are a number of different types of panoramic cameras. One of the most popular was of the fixed, curved film plane type with a moving lens. This is the only subminiature panoramic camera that was ever manufactured. It used 16mm film carried in special cassettes. The image it produced was 10mm wide and 52mm long.

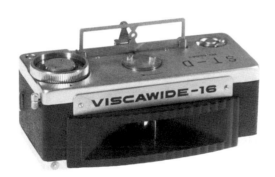

Asahi Pentax S-3 1961
Asahi Optical Company, Ltd., Tokyo
L84:061:184
Loaned by Japan Camera Inspection Institute,
 Tokyo

The Pentax S-3 was one of the earliest sophisticated 35mm single-lens reflex cameras to offer a partially coupled type of external exposure meter. A CdS type meter was mounted on the top of the camera and coupled to the shutter speed dial. By matching a needle reading on the meter, the user simultaneously adjusted the shutter speed.

Mamiya Automatic 35 EEF 1961
Mamiya Camera Company, Ltd., Tokyo
L84:061:185
Loaned by Japan Camera Inspection Institute,
 Tokyo

The Mamiya Automatic 35 EEF was the first camera manufactured in Japan to take advantage of the recently introduced miniature "peanut" type of flashbulb. It had a flash reflector that was completely integrated into the camera body. Exposure control was semi-automatic.

Graphic 35 Jet 1961
Kowa Company, Ltd., Nagoya
74:031:81
International Museum of Photography at George
 Eastman House
Gift of Graflex Corporation

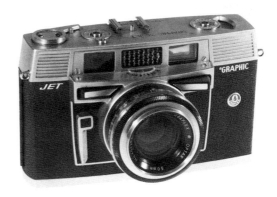

The Graphic 35 Jet was a cooperative design effort
of the Graflex Corporation in the United States
and Kowa in Japan. It was the first and only cam-
era to use gas pressure to advance the film and
cock the shutter. A standard CO_2 cartridge of the
type used to charge seltzer water bottles was
inserted in the camera and powered a special
motor which performed the mechanical functions
noted. The Graphic 35 Jet was of the rangefinder
type, the focusing controls were dual pushbuttons
located on each side of the lens.

Canon 7 1961
Canon Camera Company, Inc., Tokyo
L84:061:186
Loaned by Japan Camera Inspection Institute,
 Tokyo

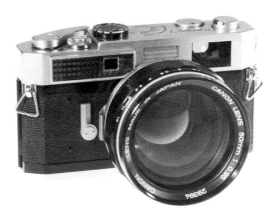

The f/0.95 lens fitted on the Canon 7 was the fast-
est made by any manufacturer at the time for a
camera of this format. An unusual feature of the
Canon 7 body was that it could use most Leica
screw mount lenses in addition to the special bay-
onet mounted f/0.95 lens supplied with the
camera.

Ricoh Auto 35 V 1961
Ricoh Company, Ltd., Tokyo
L84:061:187
Loaned by Japan Camera Inspection Institute,
 Tokyo

The Ricoh Auto 35 V is a simple amateur 35mm
camera and the first to be manufactured in Japan
fitted with a zone focusing scale. Instead of being
marked in feet or meters, symbols indicating near,
medium distant, or far subjects are used, sim-
plifying operation.

Fujica 35 Auto M 1961
Fuji Photo Film Co., Ltd., Tokyo
L84:061:188
Loaned by Japan Camera Inspection Institute,
 Tokyo

The Fujica 35 Auto M is a fixed lens rangefinder
type 35mm camera with shutter priority type of
automatic exposure control. A unique feature of
the exposure system in this camera is an automatic
override that will lengthen the exposure if the
light level is too low for the selected speed.

Olympus Pen EES 1962
Olympus Optical Company, Ltd., Tokyo
L84:061:189
Loaned by Japan Camera Inspection Institute,
 Tokyo

The Olympus Pen EES was the first camera manu-
factured in Japan equipped with a built-in, pro-
grammed, leaf type shutter. A programmed shutter
automatically adjusts both shutter speed and aper-
ture to obtain correct exposure. In simple cameras
designed for amateur use, there is generally no
method of over-riding the system.

日本製カメラの変遷

**THE
EVOLUTION
OF THE
JAPANESE
CAMERA**

Yashica Sequelle 1962
Yashica Company, Ltd., Suwa
74:028:3114
International Museum of Photography at
George Eastman House

This is the first camera to be manufactured in Japan with an electric motor to advance the film. The integral motor drive was powered by three batteries housed in the camera. When the film was used up, the motor drive stopped automatically. Exposure control was of the semi-automatic type.

Taron Marquis 1962
Taron Co., Ltd., Tokyo
L84:061:190
Loaned by Japan Camera Inspection Institute,
 Tokyo

This is a 35mm rangefinder type camera with a fixed lens. It was the first camera of the range-finder type to be fitted with the vastly more sensitive improved Cadium Sulfide or CdS light sensing system. The switch activating the meter system is in the winding lever and turned on when the lever is moved away from the body.

Minolta SR-7 1962
Minolta Camera Company, Ltd., Osaka
L84:061:191
Loaned by Japan Camera Inspection Institute,
 Tokyo

Selenium photocells generate their own power. This energy moves the needle on a meter and, with appropriate index marks, gives the correct

exposure. In the early 1960s, a much improved and vastly more sensitive system of measuring light was devised. A Cadium Sulfide or CdS cell is part of a relatively simple circuit powered by a small battery. The battery greatly amplifies the light, making possible readings under very low light situations. The Minolta SR-7 was the first single-lens reflex camera to be fitted with a CdS cell to be manufactured in Japan.

Nikkorex Zoom 35 1962
Nippon Kogaku K.K., Tokyo
L84:006:9
Loaned by Nippon Kogaku K.K., Tokyo

The Nikkorex was the first 35mm camera fitted with a permanently mounted zoom lens to be manufactured in the world. The focal length range of 43mm to 86mm provided medium wide angle to medium telephoto capability.

Konica FSW 1962
Konishiroku Photo Industry Co., Ltd., Tokyo
L84:061:192
Loaned by Japan Camera Inspection Institute,
 Tokyo

The "W" in the FSW after the camera name stands for watch. This was the first camera of Japanese manufacture with a data recording back built onto the camera. Called the Konica Time Registrar, it consisted of a special wristwatch, an optical system and miniature electronic flash. The watch face was optically reduced and projected onto the lower left-hand corner of the image. The electronic flash made the exposure recording the data on the film.

Konica EE Matic 1963
Konishiroku Photo Industry Co., Ltd., Tokyo
L84:061:193
Loaned by Japan Camera Inspection Institute,
 Tokyo

The Flashmatic system of semi-automatic flash exposure control provided a reliable means of coupling a flash (bulb or electronic) to a camera. After the guide number had been set, the aperture adjusted itself automatically when camera to subject distance was set. It was the first Japanese camera with this feature.

Olympus Pen F 1963
Olympus Optical Company, Ltd., Tokyo
L84:161:1
Loaned by Mr. Paul Doering, Rochester, New York

The Olympus Pen F was the central component in a half frame, single-lens reflex system. It was equipped with an unusual rotary type shutter that would synchronize at all shutter speeds. A large variety of interchangeable lenses were available.

Canon Demi 1963
Canon Camera Company, Tokyo
L84:061:194
Loaned by Japan Camera Inspection Institute,
 Tokyo

The viewfinder on the Canon Demi is of the "binocular-type". In practice this means that it is unusually bright, sharp and well-defined. The Demi is a half frame 35mm camera with a semi-automatic type of exposure system.

Topcon RE Super 1963
Tokyo Optical Company, Tokyo
L84:061:195
Loaned by Japan Camera Inspection Institute,
 Tokyo

The 35mm single-lens reflex Topcon was the first camera to feature a built-in metering system with the light sensitive photocell mounted on the mirror. Most professional 35mm single-lens reflexes have interchangeable finders. The traditional mounting place for the sensing meter was in the finder, complicating the process of changing viewfinder types. By mounting the cell on the mirror, the automatic exposure system was completely independent of the finder optics.

Kowa H 1963
Kowa Company, Ltd., Nagoya
L84:061:196
Loaned by Japan Camera Inspection Institute,
 Tokyo

The Kowa H was the first Japanese produced camera of the 35mm single-lens reflex type that combined a leaf shutter with a built-in, through-the-lens metering system. Exposure information was visible in a window on top of the camera and in the viewfinder. The auto exposure system was of the programmed variety, but a manual override was included for special situations.

Nikonos Camera 1963
Nippon Kogaku K.K., Tokyo
L84:006:7
Loaned by Nippon Kogaku K.K., Tokyo

The French firm of La Spirotechnique S.A. designed and marketed on a limited basis an underwater camera called the Calypso. In 1963, Nippon Kogaku made a number of important engineering changes and introduced the camera as the Nikonos. It was the first camera in the world designed for underwater photography that did not need an elaborate special housing. It was pressure proof to a depth of 160 feet. Lenses were interchangeable and in addition to the standard 35mm lens, a special wide angle lens for underwater use only was available. There have been a number of subsequent models of the Nikonos greatly refining the original design. It is the most popular camera of its type ever produced.

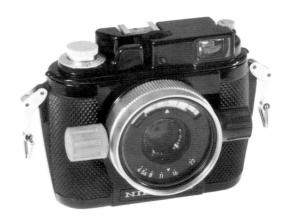

Canon Dial 35 1963
Canon Camera Company, Tokyo
84:167:1
International Museum of Photography at George
 Eastman House
Gift of Donald Fosnaught

The unusual Dial 35 was the first camera of Japanese manufacture to feature a clockworks mechanism for both advancing and rewinding the film. The name "Dial" is derived from the appearance of the ring of photocells that surround the lens which resemble the dial on a telephone.

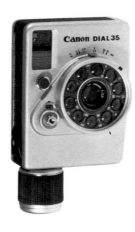

Minolta Hi-Matic 7 1963
Minolta Camera Company, Ltd., Osaka
L84:061:197
Loaned by Japan Camera Inspection Institute,
 Tokyo

This was the first model Japanese camera where the automatic exposure sensing cell was mounted immediately adjacent to the lens. This resulted in more accurate exposure readings. Otherwise the camera was of the standard 35mm rangefinder variety.

Ricoh Auto Shot 1964
Ricoh Company, Ltd., Tokyo
74:28:3215
International Museum of Photography at George
 Eastman House

The Ricoh Auto Shot is a fixed lens 35mm full frame camera with a clockworks type of automatic film advance. An unusual feature is the special lenscap which doubles as a flashholder for "peanut" AG-1 type flashbulbs.

Ricoh Rapid Half 1964
Ricoh Company, Ltd., Tokyo
L84:061:199
Loaned by Japan Camera Inspection Institute,
 Tokyo

The Ricoh Rapid Half utilized the Agfa Rapid Cassette system. It was the first of Japanese manufacture for half frame photography using Agfa spools.

Argus 260 Automatic 1964
Mamiya Camera Company, Ltd., Tokyo
L84:061:198
Loaned by Japan Camera Inspection Institute,
 Tokyo

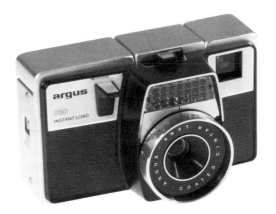

In 1963, the Eastman Kodak Company introduced
the 126 Instamatic* cassette loading system. The
Argus 260 was the first camera of Japanese manu-
facture to utilize this new easy loading amateur
format.

Kowa SW 1964
Kowa Company, Ltd., Nagoya
L84:061:200
Loaned by Japan Camera Inspection Institute,
 Tokyo

The SW stands for Super Wide on this 35mm full
frame fixed lens camera. It was the first model to
be produced in Japan exclusively for wide angle
photography.

Pentax SP 1964
Asahi Optical Co., Ltd., Tokyo
L84:061:201
Loaned by Japan Camera Inspection Institute,
 Tokyo

The Pentax Spotmatic was the first camera of the
single-lens reflex type to incorporate a built-in,
through-the-lens exposure system. This feature
proved so popular that it was quickly adapted by
nearly every manufacturer. Used initially primarily
by amateurs, semi-automatic exposure control
soon became popular with professionals. Today it
is nearly impossible to buy a camera without this
feature.

Ricoh 35 K Rapid 1964
Ricoh Company, Ltd., Tokyo
L84:061:202
Loaned by Japan Camera Inspection Institute,
 Tokyo

The Ricoh 35 K Rapid used the 35mm Agfa Rapid
spool system and was the only camera ever manu-
factured for Agfa spools for the full frame format.
An unusual mechanical sensor automatically
adjusted the ASA of the camera when different
film spools were inserted. A simplified exposure
table on the top of the camera served as an aid to
the photographer.

Fujicarex II 1964
Fuji Photo Film Co., Ltd., Tokyo
L84:061:203
Loaned by Japan Camera Inspection Institute,
 Tokyo

The Fujicarex II was the first camera of Japanese
manufacture for the 35mm format with simplified
lens interchangeability. The front element only
was exchanged for wide angle or medium tele-
photo photography. Exposure control was semi-
automatic.

Topcon Uni 1964
Tokyo Optical Company, Tokyo
L84:061:204
Loaned by Japan Camera Inspection Institute,
 Tokyo

The Topcon Uni was an unusual single-lens reflex
35mm camera with interchangeable lenses and a
leaf shutter instead of the focal plane variety usu-
ally used on cameras of this type. It was the first
camera with a leaf shutter equipped with a
through-the-lens metering system.

*Instamatic is a trademark of the Eastman Kodak Company

日本製カメラの変遷

THE EVOLUTION OF THE JAPANESE CAMERA

Koni Omega Rapid 1965
Konishiroku Photo Industry Co., Ltd., Tokyo
L84:061:205
Loaned by Japan Camera Inspection Institute,
 Tokyo

This is a press type camera for 6 x 7 cm medium format photography. The Koni Omega Rapid was the first of this type for both the 120 and 220 format. The backs were interchangeable and the user selected one or the other. The lenses were interchangeable.

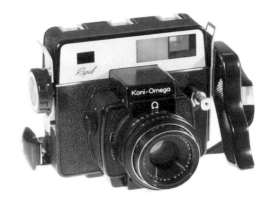

Minolta Autocord CdS 1965
Minolta Camera Company, Ltd., Osaka
L84:061:206
Loaned by the Minolta Camera Company, Osaka

The medium format twin-lens Minolta Autocord CdS was the first camera to be manufactured in Japan that could accept both standard 120 paper-backed and 220 film that permits twice the number of exposures on a single roll, which had been recently introduced by the Eastman Kodak Company. The pressure plate could be changed to compensate for the thinner 220 material that was not paperbacked.

Canonet QL 17 1965
Canon Camera Company, Ltd., Tokyo
L84:061:207
Loaned by Japan Camera Inspection Institute,
 Tokyo

The QL in the camera name stands for Quick Loading. The Canonet QL 17 was the first camera in the world with an effective quick loading system for 35mm cassettes. It is a fixed lens camera fitted with a semi-automatic type of exposure control.

Minolta 24 Rapid 1965
Minolta Camera Company, Ltd., Osaka
L84:061:208
Loaned by Japan Camera Inspection Institute,
 Tokyo

The Minolta 24 Rapid utilized the Agfa Rapid Cassette system and the unusual 24 x 24 mm format first used on Robot cameras made in Germany. The shutter is of the programmable type, but there is a manual override system not generally found on amateur cameras.

Canon Pellix 1965
Canon, Inc., Tokyo
74:028:3054
International Museum of Photography at George
 Eastman House
Gift of Canon, Inc.

In a single-lens reflex camera, a mirror is mounted in the light path behind the lens to reflect the image to the viewfinder. This mirror must swing up out of the way before an exposure can be made. The mechanics needed for this task are complex and a possible source of vibration. In the Canon Pellix, a pellicle mirror, a very thin partially mirrored film, is mounted in place of the mirror. Part of the light is reflected to the viewfinder, the rest passes directly to the film plane. This eliminates the mechanical swinging mirror and results in smoother operation; however, light losses in the system so lowered the optical efficiency that it was only marginally popular. The Canon Pellix was the first camera to use a spot reading type of through-the-lens exposure system.

Canon Demi C 1965
Canon, Inc., Tokyo
L84:061:209
Loaned by Japan Camera Inspection Institute,
 Tokyo

The Canon Demi C was basically a simple camera
fitted with a match needle type of automatic
exposure control. The camera offered a somewhat
unusual feature. There was limited lens inter-
changeability. In addition to the standard 28mm
lens, a 50mm medium telephoto was available.
The optical portion of the lens shutter assembly
was the only part that was changed. The leaf shut-
ter remained fixed to the camera.

Yashica Electro Half 1965
Yashica Company, Ltd., Suwa
L84:061:210
Loaned by Japan Camera Inspection Institute,
 Tokyo

The first camera to be fitted with both an elec-
tronically controlled shutter combined with fully
automatic exposure control of the programmed
type was the half frame Yashica Electro Half.

Yashica Lynx 14 1965
Yashica Company, Ltd., Suwa
L84:139:1
Loaned by Eastman Kodak Patent Department
 Museum, Rochester, New York

At the time of its introduction, the Yashica Lynx
had the fastest lens (f/1.4) fitted to a fixed lens
camera of this type. A match needle type of semi-
automatic exposure control and rangefinder focus-
ing were other features of this camera.

Yashica Half 17 EE Rapid 1965
Yashica Company, Ltd., Suwa
L84:061:211
Loaned by Japan Camera Inspection Institute,
 Tokyo

The Yashica Half 17 EE Rapid utilized the Agfa
Rapid Cassette system developed in Germany. The
f/1.7 lens was the fastest available on a half frame
camera at the time. The shutter was of the pro-
grammed type, automatically controlling both
aperture and speed.

Olympus Pen EM 1965
Olympus Optical Company, Ltd., Tokyo
L84:061:212
Loaned by Japan Camera Inspection Institute,
 Tokyo

The Olympus Pen EM was a half frame 35mm
camera fitted with an integral electric motor drive
for automatic film advance and rewind, the first
such system fitted to any camera.

Olympus 35 LE 1965
Olympus Optical Company, Ltd., Tokyo
L84:061:213
Loaned by Japan Camera Inspection Institute,
 Tokyo

The Olympus Optical Company took advantage of
miniaturized electronic components that were
becoming available to produce the first camera

with a programmed shutter for automatic
exposure control. A fully programmed electronic
shutter controls both shutter speed and aperture.
In cameras designed for amateur use, there is no
override system. The Olympus 35 LE was also
equipped with an electronically coupled elec-
tronic flash system of the flashmatic type. Setting
the flash guide number and distance setting auto-
matically sets the correct aperture for a good
exposure.

日本製カメラの変遷

Fotochrome 1965
Petri Camera Company, Inc., Tokyo
74:028:3054
International Museum of Photography at George
 Eastman House

The Fotochrome camera designed in the U.S. by Fotochrome, Inc., was manufactured under contract by the Petri Camera Company. It was loaded with a color photographic paper of the reversal type and made 10 exposures on a roll. Since the process was somewhat cumbersome and the color fidelity substandard, it was never very popular.

Konica EE matic S 1965
Konishiroku Photo Industry Co., Ltd., Tokyo
L84:061:214
Loaned by Japan Camera Inspection Institute,
 Tokyo

Manufacturers of 35mm cameras have been seeking improved and simplified loading systems for a number of years. The Konica EE matic S was the first 35mm camera to feature a greatly improved quick loading system. The takeup spool is of a special design to facilitate threading the film. Otherwise it is a standard fixed lens 35mm rangefinder camera with automatic exposure control.

Yashica EZ-matic 4 1965
Yashica Company, Ltd., Suwa
L84:061:215
Loaned by Japan Camera Inspection Institute,
 Tokyo

The Yashica EZ-matic 4 had the fastest lens (f/1.9) fitted to a camera for the 126 Instamatic* format at the time. Exposure control was automatic.

Yashica Atron 1965
Yashica Company, Ltd., Suwa
L84:061:216
Loaned by Japan Camera Inspection Institute,
 Tokyo

The subminiature (8 x 11 mm) format introduced in the Minox before the Second World War was used for the first time in Japan in the Yashica Atron. A removable flashholder for the "peanut" AG-1 flashbulb is fitted to the camera.

Argus 264 Automatic 1965
Mamiya Camera Company, Ltd., Tokyo
L84:061:217
Loaned by Japan Camera Inspection Institute,
 Tokyo

The Argus 264 used the 126 Instamatic* format introduced by the Eastman Kodak Company in 1963. It was the first camera using this format manufactured in Japan with a receptacle for a flashcube. It is basically a very simple amateur camera with automatic exposure control.

Konica Autorex 1965
Konishiroku Photo Industry Co., Ltd., Tokyo
L84:061:218
Loaned by Japan Camera Inspection Institute,
 Tokyo

The Konica Autorex is an interchangeable lens 35mm single-lens reflex camera for both the full frame and the half frame format. Activating a small lever on the camera masks down the picture area and adjusts the counter. This is the only dual-format 35mm camera made in recent times.

Minolta SR-T 101 1966
Minolta Camera Company, Ltd., Osaka
L84:061:219
Loaned by Japan Camera Inspection Institute,
 Tokyo

The Minolta SR-T 101 is an interchangeable lens, 35mm single-lens reflex camera with an unusual automatic metering system. The photo sensors in the camera take separate readings of the upper and lower portions of the picture and average them with a bias for more exposure in the bottom area. This is based on the fact that most pictures consist of a bright sky area and a relatively dark foreground. The metering system in this camera was designed to compensate for this and give a more accurate exposure.

Keystone Reflex K 1020 1966
Mamiya Camera Company, Ltd., Tokyo
L84:061:220
Loaned by Japan Camera Inspection Institute,
 Tokyo

The popular 126 Instamatic* format introduced
by the Eastman Kodak Company in 1963 was used
in the Keystone Reflex K 1020. It was the first
single-lens reflex camera to be manufactured in
Japan for this format, and was fitted with a fixed
lens and an automatic exposure control system.

Yashica Half 14 1966
Yashica Company, Ltd., Suwa
L84:061:221
Loaned by Japan Camera Inspection Institute,
 Tokyo

This is a fixed lens half frame 35mm camera with
an unusually fast f/1.4 lens. This was the fastest
lens offered on a fixed lens half frame camera.
Exposure control is automatic.

Marshal Press Camera 1966
Marshal Optical Co., Ltd., Tokyo
L84:061:222
Loaned by Japan Camera Inspection Institute,
 Tokyo

This is a press type camera with 120 rollfilm back
for 8 exposures on a roll. The Marshal Press Cam-
era is fitted with a special Nikkor lens of the triple
convertible type. There are two add-on element
groups which provide a total of three focal
lengths, 105, 135, and 150mm. This was the only
lens manufactured by Nippon Kogaku of this type
that changed focal length by front element addi-
tion only. The coupled rangefinder worked with
all three focal lengths.

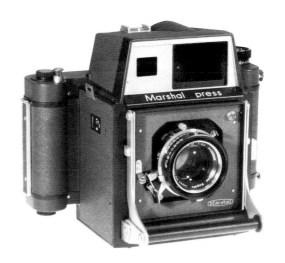

Ricoh Super Shot 24 1966
Ricoh Company, Ltd., Tokyo
L84:061:223
Loaned by Japan Camera Inspection Institute,
 Tokyo

The Ricoh Super Shot 24 is a fixed lens 35mm
camera with a clockworks type, automatic film
advance system. The viewfinder is equipped with
a focusing aid. An illuminated area in the view-
finder is adjusted to match the size of a human
head. This is a reasonably accurate method of
achieving correct focus.

*Instamatic is a trademark of the Eastman Kodak Company

日本製カメラの変遷

**THE
EVOLUTION
OF THE
JAPANESE
CAMERA**

Minolta Autopak 500 1966
Minolta Camera Co., Ltd., Osaka
L84:061:224
Loaned by Japan Camera Inspection Institute,
 Tokyo

The Minolta Autopak 500 is a very simple camera
for use with the 126 Instamatic* format developed
by the Eastman Kodak Company. It has an "intel-
ligent" flash system. A flashcube can be left per-
manently in place on the camera. It will fire only
if the light level is too low for a regular exposure.

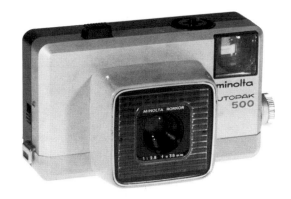

Miranda Sensorex 1966
Miranda Camera Company, Ltd., Osaka
L84:061:225
Loaned by Japan Camera Inspection Institute,
 Tokyo

The early automatic exposure systems fitted to
35mm single-lens reflex cameras were generally of
the averaging type. That is, they integrated the
total light coming through the optical system and
established an average exposure. The Miranda Sen-
sorex is equipped with a spot metering system.
This requires more skill on the part of the photog-
rapher but is superior in many photographic situ-
ations.

Yashica EZ matic Electronic Camera 1967
Yashica Company, Ltd., Suwa
L84:061:226
Loaned by Japan Camera Inspection Institute,
 Tokyo

The Yashica EZ matic Electronic Camera, designed
for use with the 126 Instamatic* format, was fitted
with an automatic exposure system for both day-
light and flash photography. Standard flashcubes
were used and the light reflected back from the
subject when the flash was fired automatically
adjusted the aperture to insure correct exposure.

Koni-Omega Rapid M 1967
L84:163:1
Loaned by Berkey Marketing Companies
 New York, New York

The Koni-Omega Rapid M is a medium format 6 x
7 cm press type camera with rangefinder focusing.
Both the lenses and backs are interchangeable.
The film is advanced rapidly by a pull-push lever
mounted on the film back.

Olympus Pen FT 1967
Olympus Optical Company, Ltd., Tokyo
L84:061:227
Loaned by Japan Camera Inspection Institute,
 Tokyo

The Olympus Optical Company manufactured the
only single-lens reflex cameras for the half frame
format. This camera was fitted with a through-the-
lens metering system that was operated manually
to set the exposure. The f/1.2 lens on this camera
was the fastest available on a camera of this type.

Konica EE matic Deluxe F 1967
Konishiroku Photo Industry Co., Ltd., Tokyo
L84:061:228
Loaned by Japan Camera Inspection Institute,
 Tokyo

The Konica EE matic Deluxe F is a 35mm fixed
lens rangefinder camera with fully automatic
exposure control. It is fitted with a flash recep-
tacle that could use either flashcubes or the minia-
ture AG-1 type of flashbulb.

Mamiya Sekor 1000 DTL 1967
Mamiya Camera Company, Ltd., Tokyo
L84:061:229
Loaned by Japan Camera Inspection Institute,
 Tokyo

The automatic exposure system in this 35mm single-lens reflex had the dual capability of making both spot and average readings. This feature which is of great importance in many situations did not become generally available for many years after the introduction of this model.

Koni-Omegaflex M 1968
Konishiroku Photo Industry Co., Ltd., Tokyo
74:37:251
International Museum of Photography at George
 Eastman House

The Koni-Omegaflex M was the only twin-lens reflex manufactured in any country with both interchangeable lenses and backs. This camera was very popular with wedding photographers who found the ability to change backs quickly particularly useful.

Yashica Lynx 5000 E 1968
Yashica Company, Ltd., Suwa
L84:061:230
Loaned by Japan Camera Inspection Institute,
 Tokyo

The Yashica Lynx 5000 E is a fixed lens 35mm camera fitted with an automatic exposure system that combined an IC (integrated circuit) with a meter based on the principle of the wheatstone bridge. A balanced circuit could be achieved by adjusting the aperture and shutter speed, at which time a small light came on. It is a relatively simple system with no mechanical moving parts and is very sturdy.

Rittreck 6 x 6 1968
Musashino Koki K.K., Kawasaki
L84:061:231
Loaned by Japan Camera Inspection Institute,
 Tokyo

Single-lens reflex medium format cameras generally have relatively slow optics. The Rittreck 6 x 6 is the only camera of its type, a 6 x 6 cm 120 rollfilm, single-lens reflex with an f/2.0 lens. This is an extraordinarily fast lens for a camera of this size.

Konica FTA 1968
Konishiroku Photo Industry Co., Ltd., Tokyo
L84:061:232
Loaned by Japan Camera Inspection Institute,
 Tokyo

The Konica FTA is a 35mm single-lens reflex camera with a match needle type of semi-automatic exposure control system. In this Konica model, the scale in the viewfinder automatically readjusts itself when lenses of different speeds are used to insure correct readings. No further compensation was necessary.

Kowa Six 1968
Kowa Company, Ltd., Nagoya
L84:061:233
Loaned by Japan Camera Inspection Institute,
 Tokyo

The Kowa Six is a medium format 6 x 6 cm camera with interchangeable lenses and finders. It was the first to be manufactured in Japan fitted with a between-the-lens shutter. This type of shutter can be synchronized at all speeds with an electronic flash and is frequently preferred by many users.

Teflex 1968
Nichiryo International Corp., Tokyo
L84:061:234
Loaned by Japan Camera Inspection Institute,
 Tokyo

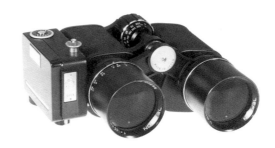

The Nichiryo International Corporation manufactured several different types of unusual instruments that were a combination of either a prism monocular or binoculars and a camera. This is the binocular version. A half frame 35mm camera is fitted to the right hand portion of a pair of 7 x 50 binoculars. A beam splitter enables the user to make a picture of the area covered by the binocular optics.

Perma Matic 618 1968
Taron Company, Ltd., Tokyo
L84:061:235
Loaned by Japan Camera Inspection Institute,
 Tokyo

The Perma Matic 618 was built for use with the Instamatic* 126 format introduced in 1963 by the Eastman Kodak Company. It is the first camera of Japanese manufacture to feature a built-in electronic flash unit.

Petri Color 35 1968
Petri Camera Company, Inc., Tokyo
L84:061:236
Loaned by Japan Camera Inspection Institute,
 Tokyo

In this compact full frame 35mm camera, all the major camera functions relating to distance and exposure are displayed in the viewfinder. This is the first camera of its type to incorporate this feature.

Fujica G-690 1968
Fuji Photo Film Co., Ltd., Tokyo
74:028:3082
International Museum of Photography at George
 Eastman House
Gift of Ehrenreich Photo Optical Industries, Inc.,

The Fujica G-690 is a hand held rangefinder type camera with interchangeable lenses that has been scaled up for 6 x 9 cm medium format photography. It handles like a 35mm camera except for its increased size and weight. However, the large negative it yields is very important for many types of photography.

Canon EX-EE 1968
Canon, Inc., Tokyo
L84:061:237
Loaned by Japan Camera Inspection Institute,
 Tokyo

The Canon EX-EE is a fully automatic single-lens reflex camera with lens interchangeability. However, only the front element needs to be exchanged. Changing the focal length of the optics does not disturb the automatic exposure functions of the camera.

Yashica TL Electro X 1968
Yashica Company, Ltd., Suwa
L84:061:238
Loaned by Japan Camera Inspection Institute,
 Tokyo

Electronic control of the focal plane shutter is virtually a standard feature on all modern 35mm single-lens reflex cameras. This feature first appeared in the Yashica TL Electro X introduced more than 15 years ago.

Olympus 35 SP 1969
Olympus Optical Company, Ltd., Tokyo
L84:061:239
Loaned by Japan Camera Inspection Institute,
 Tokyo

Fixed lens 35mm automatic exposure cameras are generally limited to a single type of automatic exposure control that averages the total light reading. The Olympus 35 SP has a dual system. By depressing a button on the back of the camera, the photographer can take a spot reading of the object he wishes to give exposure preference.

Bell & Howell Autoload 342 1969
Canon, Inc., Tokyo
L84:061:240
Loaned by Japan Camera Inspection Institute,
 Tokyo

This is a camera for the Instamatic* 126 format developed by the Eastman Kodak Company. It features an unusual focusing system. Called Focus-Matic, it is actually a single window rangefinder. The camera is aimed at the base of the object you wish to photograph and a lever depressed. This automatically measures the angle between the object and the camera which can be converted to distance. The lens is then set automatically for this distance. This very simple but effective system greatly reduced the cost of the camera.

Ricoh 126 C Flex 1969
Ricoh Company, Ltd., Tokyo
L84:061:241
Loaned by Japan Camera Inspection Institute,
 Tokyo

The Ricoh 126 C Flex is a single-lens reflex camera for use with the Instamatic* 126 format developed by the Eastman Kodak Company. It is the only model for this format with interchangeable lenses made in Japan.

Asahi Pentax 6 x 7 1969
Asahi Optical Company, Ltd., Tokyo
74:28:3083
International Museum of Photography at George
 Eastman House
Gift of Asahi Optical Company

The Asahi Pentax 6 x 7 was the first camera in the world to combine the design of an eye-level pentaprism single-lens reflex with the 6 x 7 cm format. The appearance of the camera is that of a very large 35mm camera, and all the controls and other features are similar. A full line of interchangeable lenses are available.

*Instamatic is a trademark of the Eastman Kodak Company

日本製カメラの変遷

New Canonet QL 17 1969
Canon, Inc., Tokyo
L84:061:242
Loaned by Japan Camera Inspection Institute,
 Tokyo

The Canonet QL 17 is a compact 35mm range-finder camera that can be fitted with an electronic flashgun that couples to the automatic shutter. If the batteries in the flash are low or it is not completely charged, the very high aperture (f/1.7) lens opens to increase the exposure.

Minolta Hi-Matic 11 1969
Minolta Camera Company, Ltd., Tokyo
L84:061:243
Loaned by Japan Camera Inspection Institute,
 Tokyo

The Minolta Hi-Matic 11 is a fixed lens rangefinder camera equipped with a shutter priority automatic exposure control system. This was the first production camera to combine a programmed shutter with automatic exposure control.

Minolta 16 MG-S 1969
Minolta Camera Company, Ltd., Osaka
L84:061:244
Loaned by Japan Camera Inspection Institute,
 Tokyo

The subminiature Minolta 16 MG-S utilized a special Minolta cassette not compatible with any other camera. This model used a slightly larger 12 x 17 mm format than was usual with cameras of this size. Exposure control was automatic.

Konica Electron Camera 1969
Konishiroku Photo Industry Co., Ltd., Tokyo
L84:061:245
Loaned by Japan Camera Inspection Institute,
 Tokyo

The Konica Electron was a fixed lens 35mm rangefinder camera with an interesting feature to control flash exposures. A photocell metered the light reflected from the subject during a flash exposure and closed down the shutter as soon as enough light had reached the film.

Ricoh TLS 401 1970
Ricoh Company, Ltd., Tokyo
L84:061:246
Loaned by Japan Camera Inspection Institute,
 Tokyo

This 35mm single-lens reflex features a combination eye-level pentaprism finder and a waist level reflex finder. By activating a knob on the side of the pentaprism, a small mirror could be moved into position redirecting the light upwards.

Mamiya RB 67 Professional 1970
Mamiya Camera Co., Ltd., Tokyo
78:692:1
International Museum of Photography at George
 Eastman House

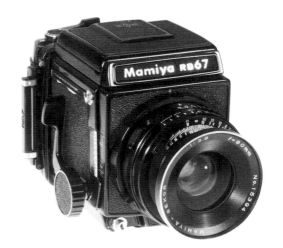

The so-called "ideal" 6 x 7 cm format is preferred by many photographers. The Mamiya RB 67 was the first camera for this format that was of the single-lens reflex type. It had a number of professional features including a revolving back, interchangeable viewing hoods, and a large variety of accessory lenses.

Convertible Horseman 1970
Komamura Photographic Company, Ltd., Tokyo
L84:061:247
Loaned by Japan Camera Inspection Institute,
 Tokyo

The Convertible Horseman was a completely
modular lightweight medium format camera. The
lensboard assembly, main body frame, and back
could be separated easily. This design lent itself to
the use of a large variety of accessory backs and
lenses. The camera was produced for a relatively
short period of time and a full accessory line never
materialized.

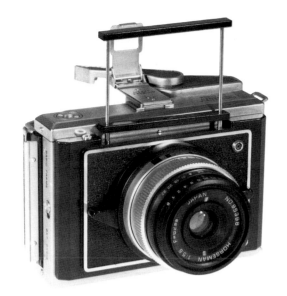

Sakura Pak 100 1970
Konishiroku Photo Industry Co., Ltd., Tokyo
L84:061:248
Loaned by Japan Camera Inspection Institute,
 Tokyo

The Sakura Pak 100 was one of the most inexpensive cameras produced in Japan in modern times. It used the Instamatic* 126 format introduced by the Eastman Kodak Company and was the first Japanese camera to employ a plastic lens.

Fujica ST 701 1970
Fuji Photo Film Co., Ltd., Tokyo
84:061:249
Loaned by Japan Camera Inspection Institute,
 Tokyo

A drawback of all automatic exposure systems for many years was that they were not sufficiently light sensitive to make readings under low light conditions. The Fujica ST 701 was the first single-lens reflex manufactured in Japan to be fitted with the vastly more sensitive silicon photocell for readings in dim light.

Canon F-1 1970
Canon, Inc., Tokyo
L84:061:250
Loaned by Japan Camera Inspection Institute,
 Tokyo

At the time of its introduction, the Canon F-1 was
the flagship of the Canon line. One of its most
important features was an optional automatic
exposure control device with a servo motor that
varied the aperture according to the light reading.
The Canon F-1 was part of an extensive photo-
graphic system with a very large variety of lenses
and special purpose devices. The sample in this
exhibition is fitted with the Servo EE Finder.

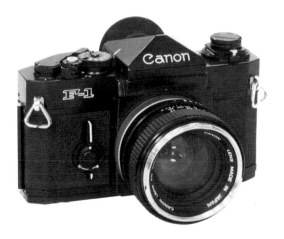

Canondate E 1970
Canon, Inc., Tokyo
74:028:3350
International Museum of Photography at George
 Eastman House

This is an automatic 35mm fixed lens rangefinder camera with an optical system for imprinting the day, month and the year on the film if the user wishes. This is the first camera with this feature built into the camera body.

*Instamatic is a trademark of the Eastman Kodak Company

日本製カメラの変遷

**THE
EVOLUTION
OF THE
JAPANESE
CAMERA**

Yashica Atoron Electro 1970
Yashica Company, Ltd., Suwa
L84:061:251
Loaned by Japan Camera Inspection Institute,
 Tokyo

The Yashica Atoron Electro uses the subminiature
Minox format developed toward the end of the
1930s in Riga, Latvia. This is the first camera with
a subminiature format fitted with an electronic
shutter. Exposure control is fully automatic.

Exacta Twin TL 1970
Cosina Company, Ltd., Nagano
L84:061:252
Loaned by Japan Camera Inspection Institute,
 Tokyo

Before the Second World War, the Ihagee Com-
pany of Dresden, Germany, manufactured an
extensive line of cameras, including the world's
first 35mm single-lens reflex camera. In the late
1960s, the Cosina Company, Ltd., manufactured
under contract a single-lens reflex camera that
could use widely available Exacta lenses. This
somewhat unusual camera contains a number of
the design features of the original Exacta in greatly
improved form.

Nicnon S 1970
Nichiryo International Corp., Tokyo
L84:061:253
Loaned by Japan Camera Inspection Institute,
 Tokyo

This is a very unusual combination of a 7 x 50
monocular telescope fitted with an auto advance
half frame 35mm camera. A beam splitter diverted
a portion of the light which was focused on the
film plane. The same firm manufactured a binocu-
lar version which is also in this exhibition. It was
popular with law enforcement agencies.

Astral S-30 Electric Eye 1970
Sedic Limited, Tokyo
L84:061:254
Loaned by Japan Camera Inspection Institute,
 Tokyo

Designed to use the Instamatic* 126 format devel-
oped by the Eastman Kodak Company, the Astral
S-30 was the first simple camera to be manufac-
tured in Japan for use with the self-igniting
Magicube flash bulb.

Olympus 35 EC-2 1971
Olympus Optical Company, Ltd., Tokyo
L84:061:255
Loaned by Japan Camera Inspection Institute,
 Tokyo

The Olympus 35 EC-2 is a compact 35mm fixed
lens automatic camera. An electronic interlock
prevents the shutter from being operated if bat-
tery power falls too low, thus preventing
improperly exposed pictures.

Asahi Pentax ES 1971
Asahi Optical Company, Ltd., Tokyo
L84:061:256
Loaned by Japan Camera Inspection Institute,
 Tokyo

The Asahi Pentax ES was the first camera with an
aperture preferred electronic exposure control
system. This system was so successful that it was
adopted by virtually every manufacturer in the
next ten years.

Zenza Bronica EC 1972
Bronica Company, Inc., Tokyo
L84:061:257
Loaned by Japan Camera Inspection Institute,
 Tokyo

This is the first camera manufactured in the world for the 6 x 6 cm medium format fitted with an electronically controlled shutter. A unique two-piece instant return mirror permitted the use of unusually deep lenses that normally could not be used with cameras of this type.

Minolta 16 QT 1972
Minolta Camera Company, Ltd., Osaka
78:1368:1
International Museum of Photography at George
 Eastman House

The Minolta 16 QT is a subminiature camera with automatic exposure control. It used a special Minolta film cassette that would not fit any other camera. The exposure data could be read in the viewfinder window.

Argus Electronic 355-X 1972
Sedic Limited, Tokyo
L84:061:258
Loaned by Japan Camera Inspection Institute,
 Tokyo

The Argus Electronic 355-X was a very inexpensive camera for the Instamatic* 126 format introduced by the Eastman Kodak Company. The fully automatic exposure control had a simple type of warning system in the viewfinder. If a red light flashed intermittently, there was sufficient light to make an exposure. If it remained on, a flashcube was needed.

Canon EX Auto 1972
Canon, Inc., Tokyo
L84:061:259
Loaned by Japan Camera Inspection Institute,
 Tokyo

Only the front element has to be changed on this model Canon single-lens reflex to change the focal length of the optics. A total of four optical sets were available from 35mm to 125mm. This system is considerably simpler than full lens interchangeability and results in reduced costs.

Miranda Sensoret 1972
Miranda Camera Company, Ltd., Tokyo
L84:061:260
Loaned by Japan Camera Inspection Institute,
 Tokyo

This simple compact 35mm camera has a system that displays the effective aperture number in the viewfinder when a flash unit is attached.

Prinzflex M-1 1972
Chinon Industries, Inc., Suwa
L84:061:261
Loaned by Japan Camera Inspection Institute,
 Tokyo

The Prinzflex M-1 is a 35mm single lens reflex of traditional design with a feature that appeals to a number of photographers. Special-effect double exposures could be made by activating a small lever mounted next to the shutter release.

Kowa UW 190 1972
Kowa Company, Ltd., Nagoya
L84:061:262
Loaned by Japan Camera Inspection Institute,
 Tokyo

The Kowa is a 35mm single-lens reflex fitted with a permanently mounted ultra wide angle 19mm lens.

*Instamatic is a trademark of the Eastman Kodak Company

Olympus M-1 1972
Olympus Optical Company, Ltd., Tokyo
L84:061:263
Loaned by Japan Camera Inspection Institute,
 Tokyo

The Olympus M-1 marked the beginning of a new
generation of 35mm single-lens reflex cameras. It
was more compact and lighter than any other
camera previously manufactured of this type with-
out sacrificing any features. The focusing screens
were interchangeable through the lens opening.
It was marketed internationally as the Olympus
OM-1.

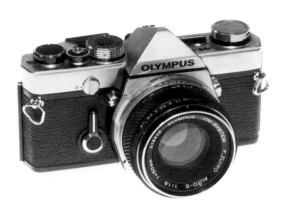

Ricoh 35 Electronic 1972
Ricoh Company, Ltd., Tokyo
L84:061:264
Loaned by Japan Camera Inspection Institute,
 Tokyo

The Ricoh 35 Electronic is a fixed lens 35mm
rangefinder camera fitted with a mechanical timer
that employs a light to signal the timing interval. It
was the first camera with this feature.

Sedic Pocket 110 1972
Sedic Limited, Tokyo
L84:061:265
Loaned by Japan Camera Inspection Institute,
 Tokyo

The very popular 110 Pocket Instamatic† format
introduced by the Eastman Kodak Company in
the United States in 1972 was first used in Japan in
the very simple Sedic 110.

Minolta XK 1973
Minolta Camera Company, Ltd., Osaka
L84:061:266
Loaned by the Minolta Camera Company

The electronic circuitry of the Minolta XK may be
activated by both a fixed position and a quick-
action switch. For quick shooting, depressing a
raised area on the front of the camera will activate
the camera's electronics. This minimizes the possi-
bility of a photographer's losing an important
shot.

**THE
EVOLUTION
OF THE
JAPANESE
CAMERA**

Cosina Hi-Lite EC 1973
Cosina Company, Ltd., Nagano
L84:061:267
Loaned by Japan Camera Inspection Institute,
 Tokyo

The Cosina Hi-Lite EC employs a fully automatic
exposure system of the aperture preferred type
that has been somewhat simplified. The exposure
reading is made the moment the lens stops down
prior to making the exposure. This eliminates one
of the mechanical interlocks and lowers the cost.

Minolta Autopak 400-X 1973
Minolta Camera Company, Ltd., Osaka
L84:061:268
Loaned by Japan Camera Inspection Institute,
 Tokyo

The Minolta Autopak 400-X is an inexpensive cam-
era designed to use the Instamatic* 126 format.
The shutter release button on the Autopak 400-X
could be retracted when not in use to prevent
accidental tripping.

Fujica ST-801 1973
Fuji Photo Film Co., Ltd., Tokyo
L84:061:269
Loaned by Japan Camera Inspection Institute,
 Tokyo

The semi-automatic exposure system on the Fujica
ST-801 displays the exposure information on an
LED (light emitting diode) in the viewfinder. It
was the first camera to use this system.

Leica CL 1973
Minolta Camera Company, Ltd., Osaka
78:686:3
International Museum of Photography at George
 Eastman House
Gift of E. Leitz, USA

The Leica CL (CL means Compact Leica) was a
joint design effort of E. Leitz, Wetzlar, Germany,
and the Minolta Camera Company. It utilized a
unique through-the-lens metering system that had
first appeared on the Leica M5. These cameras
were the first of the rangefinder type with
through-the-lens metering. It was designed to
complement the Leica system and could use most
of the Leica bayonet mount lenses. An improved
version of this camera, the Minolta CLE, is also in
the exhibit.

Fujica ST 901 1974
Fuji Photo Film Co., Ltd., Tokyo
L84:061:270
Loaned by Japan Camera Inspection Institute,
 Tokyo

An LED (light emitting diode) display in the view-
finder indicated the shutter speed the automatic
exposure control had selected in the Fujica ST
901. It was the first model to incorporate this sys-
tem as camera designs became increasingly elec-
tronic.

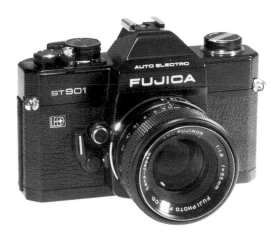

Canon EF 1973
Canon, Inc., Tokyo
81:1296:26
International Museum of Photography at George
 Eastman House
Gift of Canon U.S.A. Inc.

The viewfinder on the Canon EF had an indicator
that automatically showed the maximum aperture
of the lens fitted to the camera. This feature was
of great convenience if you changed lenses fre-
quently.

Vivitar 602 1974
West Electric Co., Osaka
L84:061:271
Loaned by Japan Camera Inspection Institute,
 Tokyo

Many of the products marketed in the U.S. under
the brand name Vivitar are made in Japan. The
Vivitar 602 was the first of the Pocket Instamatic†
110 format to incorporate a built-in electronic
flash.

Canon 110 ED 1974
Canon, Inc., Tokyo
L84:061:272
Loaned by Japan Camera Inspection Institute,
 Tokyo

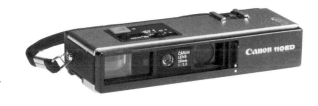

The f/2 lens fitted to the Canon Pocket Instamatic†
110 ED was the fastest available at the time on a
camera of this format.

*Instamatic is a trademark of the Eastman Kodak Company †Pocket Instamatic is a trademark of the Eastman Kodak Company

日本製カメラの変遷

Pocket Fujica 600 1974
Fuji Photo Film Co., Ltd., Tokyo
L84:061:273
Loaned by Japan Camera Inspection Institute,
 Tokyo

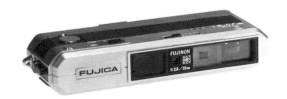

Equipped with a sophisticated automatic exposure control system and a coupled rangefinder, the Fujica 600 ranks as a premium camera of this type. It was also fitted with an indicator type of self-timer. During the self-timing interval, a small knob changed position indicating when the picture was about to be taken.

Mamiya RB-67 Pro S 1974
Mamiya Camera Co., Ltd., .Tokyo
L84:061:274
Loaned by Japan Camera Inspection Institute,
 Tokyo

The medium format Mamiya RB-67 was the largest selling medium format camera in the United States and was particularly popular with commercial photographers. It was rugged and versatile. The Pro-S version contains a number of improved features, including a device that coupled the rotating back to the mask in the viewfinder, automatically matching the format (horizontal or vertical) that the photographer had selected.

Konica C 35 EF 1974
Konishiroku Photo Industry Co., Ltd., Tokyo
L84:061:275
Loaned by Japan Camera Inspection Institute,
 Tokyo

The Konica C 35 EF is fitted with a built-in electronic flash that pops up into position and automatically turns on when a button is depressed on the front of the camera.

Zenza Bronica EC-TL 1975
Zenza Bronica Industries, Inc., Tokyo
78:1361:1
International Museum of Photography at George
 Eastman House
Gift of Ehrenreich Photo-Optical Industries, Inc.,
 Garden City, New York

The Zenza Bronica EC-TL was the first medium format camera to be fitted with an electronic shutter coupled to an automatic exposure control system. The Bronica had interchangeable backs and lenses.

Mamiya M645 1975
Mamiya Camera Company, Ltd., Tokyo
76:22:1
International Museum of Photography at George
 Eastman House
Gift of Mamiya Camera Company

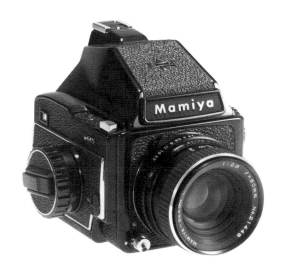

Before the Second World War, the 4.5 x 6 cm format permitting 16 exposures on a roll of 120 film was very popular but its use ceased early after the war. The M645 revived the format in the form of an automated single-lens reflex. In order to increase the spacing between images for greater ease of handling, the camera was designed to make 15 exposures on a standard 120 roll. A variety of interchangeable lenses were available.

Pocket Fujica 200F 1975
Fuji Photo Film Industry, Inc., Tokyo
L84:061:276
Loaned by Japan Camera Inspection Institute,
 Tokyo

The Fujica 110 was the first Japanese-made 110 Pocket Instamatic† camera to use the "flip-flash" designed by General Electric.

Contax RTS 1975
Yashica Co., Ltd., Tokyo
76:323:1
International Museum of Photography at George
 Eastman House
Gift of Yashica, Inc., USA

In the early 1970s, Zeiss of West Germany contracted with the Yashica Co. of Tokyo to manufacture a modern single-lens reflex with the venerable Contax name that had first appeared in 1932 on a camera manufactured by Zeiss Ikon in Jena, Germany. The camera that resulted was a cooperative design effort between Zeiss and Yashica. One of its unique features was an electromagnetic exposure release system that is extraordinarily smooth.

Olympus OM-2 1975
Olympus Optical Company, Ltd., Tokyo
L77:030:1
Loaned by Olympus Optical Company, Tokyo

The electronic sensors that monitor the light passing through the lens are embossed on the curtain of the focal plane shutter in the Olympus OM-2. This system permits particularly rapid and accurate exposure control. The same electronics could be coupled to an electronic flash for automatic flash exposures.

Fujica Date 1975
Fuji Photo Film Co., Tokyo
L84:061:277
Loaned by Japan Camera Inspection Institute,
 Tokyo

The user had the option with the Fujica Date of having the day, month, and year imprinted on each exposure. This information also appeared in the viewfinder as a reminder that it was turned on.

Tele Focal Camera 1976
Sedic, Ltd., Tokyo
L84:061:278
Loaned by Japan Camera Inspection Institute,
 Tokyo

The Tele Focal had a built-in long-focus lens that could be moved into position with a small lever on the top of the camera. Changing the focal length also masked the viewfinder.

Pocket Fujica 350 Zoom 1976
Fuji Photo Film Industry Co., Tokyo
L84:061:279
Loaned by Japan Camera Inspection Institute,
 Tokyo

The Pocket Fujica 350 Zoom was the first 110 Pocket Instamatic† camera with a built-in zoom lens. The viewfinder was coupled to the lens and varied directly as the focal length of the lens was changed. It was also parallax-corrected.

Zenza Bronica ETR 1976
Zenza Bronica Industries, Inc., Tokyo
L84:061:280
Loaned by Japan Camera Inspection Institute,
 Tokyo

The Zenza Bronica ETR was the second 4.5 x 6 cm format camera to be produced in Japan. The backs and lenses were fully interchangeable and the leaf type between-the-lens shutter electronically controlled. The electronics that governed the operation of the shutter were housed in the body of the camera and coupled to the lens by a series of contacts.

†Pocket Instamatic is a trademark of the Eastman Kodak Company

日本製カメラの変遷

**THE
EVOLUTION
OF THE
JAPANESE
CAMERA**

Throughout the history of photography, cameras and optical systems have generally been technically more advanced than available sensitized materials. For example, very high-speed shutters were available before the turn of this century, long before films fast enough to take advantage of them came along. It is difficult in reviewing the history of camera design to identify more than a handful of sweeping new concepts, yet there have been tens of thousands of different models produced by firms in many countries. Refinements, improved quality, and new combinations of ideas are the rule.

This changed with the beginning of the present era of the electro-mechanical camera. No industrial group has been more aggressive and successful than the Japanese manufacturers in adapting newly available miniaturized electronic systems to camera technology. Since the first cameras based on electronics that partially automated the picture-taking process began to emerge in the 1960s, an incredible variety of products has been created by the industry. These four cameras each pioneered in some area of this new era of camera design, and each was a successful product that incorporated features that were soon used industry-wide.

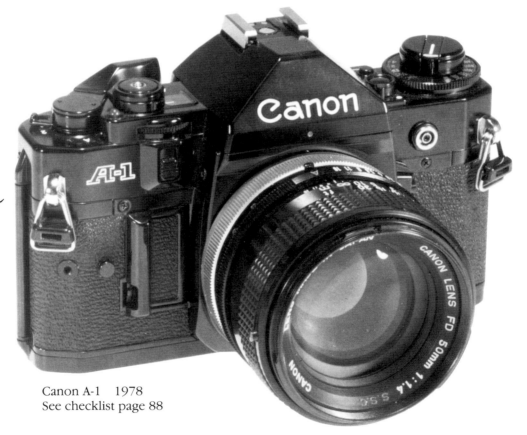

Canon A-1 1978
See checklist page 88

Fujica DL-100 1982
See checklist page 98

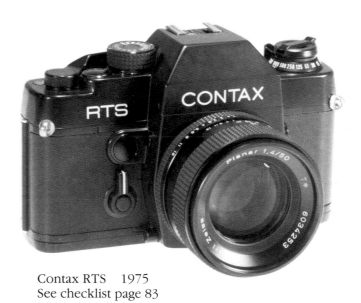

Contax RTS 1975
See checklist page 83

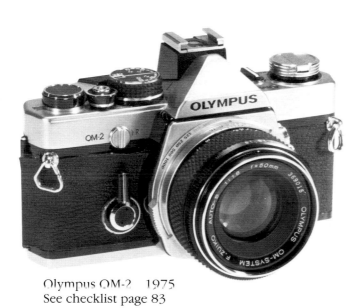

Olympus OM-2 1975
See checklist page 83

Canon AE-1 1976
Canon, Inc., Tokyo
L84:061:281
Loaned by Japan Camera Inspection Institute,
 Tokyo

An integrated circuit which is part of the electronics of the Canon AE-1 controls all exposure functions. The light-sensing system in the camera was one of the most sensitive in use at the time permitting automatic exposures under very low light conditions. A compatible electronic flash could be coupled directly to the electronics housed in the camera for fully automatic flash exposures. It was the first camera fitted with an electronic self-timer that indicated the timing interval with a flashing light.

Osanon Digital 750 Camera 1976
Yashima Optical Company, Tokyo
L84:061:282
Loaned by Japan Camera Inspection Institute,
 Tokyo

The Osanon Digital 750 was fitted with a shutter of very unusual design. The electronic shutter was of the continuously variable type and the actual shutter speed selected by the automatic exposure control system was indicated in a digital readout in the viewfinder accurate to 1/1000th of a second. The readout was in digital form, that is, 1.00 meant 1/1000th of a second, 500½ second, etc.

Minolta 110 Zoom 1976
Minolta Camera Company, Ltd., Osaka
L84:061:283
Loaned by Japan Camera Inspection Institute,
 Tokyo

The Minolta 110 Zoom was the first camera manufactured for the Pocket Instamatic† 110 format that was both a single lens reflex and fitted with a zoom lens. The lens was for normal to telephoto photography and had a macro close focusing position for extreme close-ups. Exposure control was fully automatic.

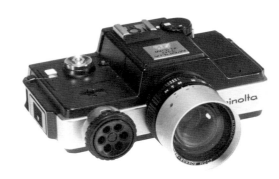

Cosina Hi-Lite CSR 1976
Cosina Company, Ltd., Nagano
L84:061:284
Loaned by Japan Camera Inspection Institute,
 Tokyo

The Cosina Hi-Lite CSR was fitted with a standard aperture priority semi-automatic exposure control system. A separate servo motor was available as an extra cost option converting the camera to fully automatic operation. The example in this exhibition is fitted with this unit.

Flash Fujica Date 1976
Fuji Photo Film Co., Ltd., Tokyo
L84:061:285
Loaned by Japan Camera Inspection Institute,
 Tokyo

Normally the user must manually set the camera to the correct film speed in order for the automatic exposure system to function properly. The Flash Fujica Date had an electronic sensing system that automatically adjusted the camera for the two most popular film speeds. It was the first camera fitted with this type of automatic sensor, and worked only with Fuji films.

Hanimex VEF 1976
Sedic, Ltd., Tokyo
L84:061:286
Loaned by Japan Camera Inspection Institute,
 Tokyo

The Hanimex VEF was the least expensive camera produced for the Pocket Instamatic† 110 format that was fitted with a built-in auxilliary close-up lens.

Asahi Pentax ME 1976
Asahi Optical Co., Ltd., Tokyo
L84:061:287
Loaned by Japan Camera Inspection Institute,
 Tokyo

The Asahi Pentax ME was the most compact and lightest 35mm single-lens reflex to be fitted with an extremely sensitive gallium photodiode for the automatic exposure system. Other features were a greatly improved quick loading device and a very accurate all-metal focal plane shutter.

Sunpak SP 1000 1977
Sunpak Corp., Tokyo
L84:061:288
Loaned by Japan Camera Inspection Institute,
 Tokyo

This is a 110 Pocket Instamatic† camera with built-in electronic flash. When not in use the viewfinder folded flush with the body of the camera and was moved to a vertical position in use. The viewfinder also was a master switch that turned off the electronic flash when the camera was not in use to prevent accidental draining of the battery.

School 110 Camera 1977
Sedic, Ltd., Tokyo
L84:061:289
Loaned by Japan Camera Inspection Institute,
 Tokyo

This simple 110 camera for use with the Pocket Instamatic† format came in the form of a do-it-yourself assembly kit.

Vivitar 742 XL 1977
West Electric Co., Osaka
L84:061:290
Loaned by Japan Camera Inspection Institute,
 Tokyo

The Vivitar 742 XL is a 110 camera for the Pocket Instamatic† format fitted with a programmed electronic shutter and coupled rangefinder. The distance and flash scales were illuminated so they could be read under zero or low light conditions.

Minolta XD 1977
Minolta Camera Company, Ltd., Osaka
84:165:1
International Museum of Photography at George
 Eastman House
Gift of Minolta, USA

The Minolta XD was the first single-lens reflex giving the user the choice of aperture or shutter preference when using the automatic exposure system.

†Pocket Instamatic is a trademark of the Eastman Kodak Company

日本製カメラの変遷

**THE
EVOLUTION
OF THE
JAPANESE
CAMERA**

Minolta XG 7 1977
Minolta Camera Company, Ltd., Osaka
L84:061:291
Loaned by Minolta Camera Company

The XG 7 was the first Minolta camera to employ a so-called touch sensor shutter release. This is an electro-magnetic switch activated by the touch of the user's finger. The moisture on the finger completed the circuit activating the automatic exposure system. This feature now appears on all of the premium Minolta cameras.

Konica C35 AF 1977
Konishiroku Photo Industry Co., Ltd., Tokyo
L84:061:292
Loaned by Japan Camera Inspection Institute, Tokyo

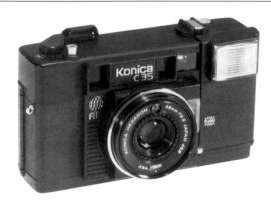

The Konica C35 AF (Auto-Focus) was the first production camera in the world to utilize a chip, designed and manufactured by the Honeywell Corp. in the United States, that provided a very compact and accurate automatic-focusing system.

Pocket Fujica 550 Auto 1978
Fuji Photo Film Co., Ltd., Tokyo
L84:061:295
Loaned by Japan Camera Inspection Institute, Tokyo

The built-in electronic flash gun on this camera was of the thyristor type which automatically adjusted light output according to the camera to subject distance. It was the only 110 Pocket Instamatic† format camera to utilize this feature.

Zenix TL-5 1978
Zenix Industries, Inc., Tokyo
L84:061:293
Loaned by Japan Camera Inspection Institute, Tokyo

The Zenix TL-5 (for Tri-Lens) was basically a very simple camera for the 110 Pocket Instamatic† format, but it incorporated a particularly interesting feature. By operating a sliding lever mounted on top of the camera, the user could choose between a standard, wide-angle, or telephoto lens. It was the least expensive multi-focal length camera made for this format.

Canon A-1 1978
Canon Inc., Tokyo
L84:061:294
Loaned by Japan Camera Inspection Institute, Tokyo

The A-1 was the first camera in the world to be fitted with a built-in computer that programmed all exposure functions. Alternately, the user had the option of selecting aperture or shutter preferred operation.

Asahi Pentax Auto 110 1978
Asahi Optical Company, Ltd., Tokyo
79:4276:1
International Museum of Photography at George Eastman House
Gift of Asahi Optical Company

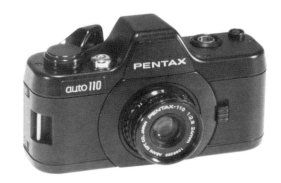

The Asahi Pentax Auto 110 was the only camera ever made for the 110 Pocket Instamatic† format that was a single-lens reflex with a full line of interchangeable lenses. Exposure control was fully automatic, and an optional motor drive was available.

Konica C 35 EFD 1979
Konishiroku Photo Industry Co., Ltd., Tokyo
L84:061:296
Loaned by Japan Camera Inspection Institute,
 Tokyo

The Konica C 35 EFD featured a built-in electronic flash unit and clock that automatically dated each exposure.

Vivitar 35EM 1978
Nitto Kogaku K.K., Suwa
L84:061:297
Loaned by Japan Camera Inspection Institute,
 Tokyo

A single lever on the front of the Vivitar 35EM opened the lens cap, moved the lens into the taking position, and prepared the shutter release. In the closed position, the camera could be safely carried in your pocket.

Minimax Camera 1978
Sugaya Optical Co., Tokyo
L84:061:298
Loaned by Japan Camera Inspection Institute,
 Tokyo

The Minimax used the popular 110 Pocket Instamatic† cassette, but the design of the camera was a scaled-down 35mm type. It was fitted with a programmed electronic shutter and automatic exposure control.

Art Panorama 240 1978
Tomiyama Seisakusho Company, Ltd., Tokyo
L84:061:299
Loaned by Tomiyama Seisakusho Company, Ltd.,
 Tokyo

There has been a revival of interest in extreme wide angle photography in recent years. In response to this market, the firm of Tomiyama Seisakusho is producing a camera capable of making 3 exposures, each 6 cm wide and 24 cm long, on standard 120 rollfilm. By adjusting the mask in the camera, it is possible to make 4 exposures each 6 x 17 cm. It is the widest angle camera of this type produced by any manufacturer.

Coca-Cola Camera 1978
Sedic, Ltd., Tokyo
L84:061:300
Loaned by Japan Camera Inspection Institute,
 Tokyo

This is a simple 110 camera for Pocket Instamatic† format housed in a facsimile Coca-Cola** can, used for promotional purposes.

Zenix Zoom TS 1978
Zenix Industries, Inc., Tokyo
L84:061:301
Loaned by Japan Camera Inspection Institute,
 Tokyo

For use with the 110 Pocket Instamatic† format the Zenix Zoom TS was fitted with a zoom lens for standard to medium-telephoto photography. It was the least expensive camera of this type to be fitted with a zoom lens.

†Pocket Instamatic is a trademark of the Eastman Kodak Company **Coca Cola is a trademark of the Coca Cola Company

Plaubel Makina 67 1978
Doi International Co., Ltd., Tokyo
81:2329:1
International Museum of Photography at George
 Eastman House
Gift of Doi International Co., Ltd., Tokyo

This very modern instrument borrows some of
the design concepts of the original Plaubel Makina
of 1932. The Makina 67 uses 120 rollfilm and is
fitted with a high performance Nikkor lens, cou-
pled rangefinder, and a built-in electronic
exposure metering device.

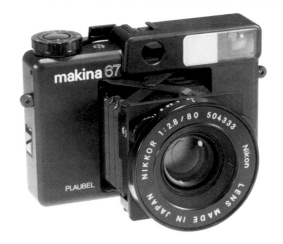

Yashica Auto Focus 1978
Yashica Company, Ltd., Tokyo
L84:061:302
Loaned by Japan Camera Inspection Institute,
 Tokyo

A focus lock on the Yashica Auto Focus camera
improved the versatility of this type of camera.
After selecting an object you wished to concen-
trate on, by depressing the focus lock you fixed
the camera at a particular setting. This eliminated
the possibility of the focus's changing inadver-
tently.

Fujica GW 690 Professional 1978
Fuji Photo Film Co., Ltd., Tokyo
L84:061:303
Loaned by Japan Camera Inspection Institute,
 Tokyo

The Fujica GW 690 Professional will make 6 x 9
cm images on 120 rollfilm. Designed for profes-
sional use, it focuses by means of a split-image
rangefinder. A unique feature of this camera is a
mechanical counter that keeps track of the total
number of exposures made through 999.

Konica FS-1 1978
Konishiroku Photo Industries Co., Ltd., Tokyo
L84:061:304
Loaned by Japan Camera Inspection Institute,
 Tokyo

The Konica FS-1 was the first 35 mm single-lens
reflex to be fitted with an integral motor drive. It
was also fitted with a semi-automatic loading
device.

**THE
EVOLUTION
OF THE
JAPANESE
CAMERA**

Ricoh FF-1 1978
Ricoh Company, Ltd., Tokyo
L84:061:305
Loaned by Japan Camera Inspection Institute,
 Tokyo

The Ricoh FF-1 is an ultra compact full frame
35mm camera of a type popularized by the Minox
35 introduced several years earlier.

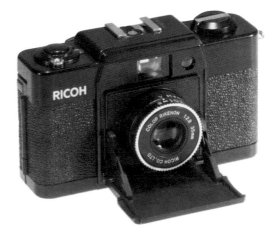

Nikon F-2 H-MD 1978
Nippon Kogaku K.K., Tokyo
L84:061:306
Loaned by Japan Camera Inspection Institute,
 Tokyo

The Nikon F-2 H-MD is a limited-production camera primarily for use with a high-speed motor drive. Instead of the usual moving mirror that rises out of the focal plane before the exposure is made, the H-MD uses a fixed partially-coated mirror. Sixty-five percent of the light passes through to the film plane, and 35% is reflected through the viewfinder. The elimination of the moving mirror makes it possible to make up to ten exposures per second.

Cosina CS-3 1979
Cosina Company, Ltd., Nagano
L84:061:307
Loaned by Japan Camera Inspection Institute,
 Tokyo

The first semi-automatic exposure systems required the user to align a needle in the viewfinder with a fixed-index point. The Cosina CS-3 was completely electronic, and instead of the mechanical needle, the user matches two LED's by moving either the aperture or shutter speed dial.

Flash Fujica Auto Focus 1979
Fuji Photo Film Co., Ltd., Tokyo
L84:061:308
Loaned by Japan Camera Inspection Institute,
 Tokyo

The auto focus system, developed by the Honeywell Corporation in the United States and used by a number of manufacturers, required a certain level of light to function properly. The Flash Fujica had a small powerful light source called a Beam Sensor fitted to the camera as a focusing aid for low light, thus extending the conditions under which the camera could be used.

Cosina VAF Auto Focus 1979
Cosina Company, Ltd., Nagano
L84:061:309
Loaned by Japan Camera Inspection Institute,
 Tokyo

The Cosina VAF Auto Focus camera was fitted with the popular system designed by the Honeywell Corp. in the United States. However, this camera permitted the user to switch off the auto focusing system if they desired and adjust the distance setting manually.

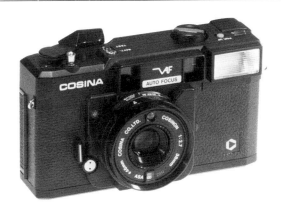

Hanimex 35 Reflex Flash 1979
Sedic Company, Ltd., Tokyo
L84:061:310
Loaned by Japan Camera Inspection Institute,
 Tokyo

The Hanimex was a very inexpensive 35mm single-lens reflex fitted with a built-in electronic flash unit. This was the first of this type to be so equipped.

日本製カメラの変遷

THE
EVOLUTION
OF THE
JAPANESE
CAMERA

Contax 139 Quartz 1979
Yashica Company, Ltd., Tokyo
L84:061:311
Loaned by Japan Camera Inspection Institute,
 Tokyo

In the Contax 139, a quartz oscillation control provides extreme shutter accuracy. It is basically an improved version of the Contax RTS that appeared several years earlier and incorporates a number of refinements.

Fujica AX-5 1979
Fuji Photo Film Co., Ltd., Tokyo
L84:061:312
Loaned by Japan Camera Inspection Institute,
 Tokyo

The Fujica AX-5 is a fully automatic single-lens reflex that incorporated the most up-to-date electronics available at the time. A built-in self timer makes an audible signal, a sequence of beeps, before releasing the shutter.

Olympus XA 1979
Olympus Optical Company, Ltd., Tokyo
84:166:1
International Museum of Photography at George
 Eastman House
Gift of the Olympus Camera Company, USA

The Olympus XA was the most compact full frame 35mm camera ever made at the time of its introduction. This was achieved partially by the use of a lens type that did not require that it be extended before use. The sliding cover that conceals the lens is also a switch that operates the electronics built into the camera.

HD-1 Fujica 1979
Fuji Photo Film Co., Ltd., Tokyo
L84:061:313
Loaned by Japan Camera Inspection Institute,
 Tokyo

The HD-1 Fujica is an all-weather camera. The lens is protected by a piece of glass and all openings in the camera chassis are weatherproofed. It is particularly useful for photographing watersports. The flash contact is an infrared beam. A standard type of electric contact would short out if it gets wet.

Minolta Weathermatic A 1979
Minolta Camera Company, Ltd., Osaka
80:708:1
International Museum of Photography at George
 Eastman House
Gift of the Minolta Camera Company

The Minolta Weathermatic is the only underwater camera made for the popular 110 Pocket Instamatic† format. Although not designed for extreme depths (it is limited to a maximum of 15 feet) it is very useful, particularly since it has a built-in electronic flash, for photographing marine life in shallow waters. Exposure control was automatic. If dropped underwater, it floats to the surface.

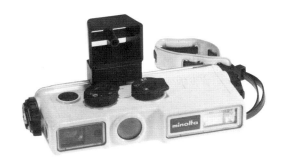

Minolta 110 Zoom SLR—Mark II 1979
Minolta Camera Company, Ltd., Osaka
L84:061:314
Loaned by Japan Camera Inspection Institute,
 Tokyo

The Minolta 110 Zoom SLR is a premium camera for the 110 Pocket Instamatic† format, fitted with a zoom lens for standard to telephoto photography and a macro position for extreme close-ups. It can be focused as close as three inches.

Mamiya ZE 1979
Mamiya Camera Company, Ltd., Tokyo
L84:061:315
Loaned by Japan Camera Inspection Institute,
 Tokyo

The Mamiya ZE is the first camera of Japanese manufacture to use an electronic coupling system between the lens and the camera body.

Canon AF 35 M 1979
Canon, Inc., Tokyo
L84:061:316
Loaned by Japan Camera Inspection Institute,
 Tokyo

The Canon AF 35 M was the first auto focusing camera to employ an infrared sensing sytem designed by Canon. The camera was totally automated. In addition to automatic exposure control, a built-in motor drive advanced and rewound the film. It was one of the most popular cameras ever introduced.

Pentax ME Super 1979
Asahi Optical Company, Ltd., Tokyo
L84:061:317
Loaned by Japan Camera Inspection Institute,
 Tokyo

The Pentax ME Super employs both fully automatic and a metered manual exposure system. In the manual mode, the shutter speed is changed by pushing one of two buttons on the top of the camera. The selected speed is indicated in the viewfinder. The data displayed in the viewfinder is comprehensive, and includes aperture, shutter speed, and the operating mode that has been selected.

Carena EF-25 1979
Zenix Industries, Inc., Tokyo
L84:061:318
Loaned by Japan Camera Inspection Institute,
 Tokyo

The lens is moved to the shooting position by opening a pair of "barn door" type of doors. The built-in electronic flash unit fits flush against the body when not in use and swings into the ready position through a 90° arc.

Ricoh AD-1 1979
Ricoh Company, Ltd., Tokyo
L84:138:01
Loaned by Ricoh Company, Ltd., Tokyo

The Ricoh AD-1 was fitted with an integral spring-wound automatic film advance. Unlike most spring advance systems, it was capable of repeat action shots up to two frames per second. The camera was simple and inexpensive and designed with the intention of providing an auto advance camera at a very modest price.

Olympus XA2 1980
Olympus Optical Company, Ltd., Tokyo
81:1296:21
International Museum of Photography at George
 Eastman House
Gift of Olympus Optical Company

The Olympus XA2 is a less expensive version of the compact XA originally introduced in 1979. It is fitted with a slightly slower lens and the rangefinder has been eliminated. The zone focusing scale always returns to the hyperfocal setting when the camera is closed, minimizing the possibility of an accidental focusing error. The hyperfocal distance is the point at which a lens will focus most subjects accurately.

†Pocket Instamatic is a trademark of the Eastman Kodak Company

Contax 137 MD Quartz 1980
Yashica Company, Ltd., Suwa
83:720:1
International Museum of Photography at George
 Eastman House
Gift of Yashica Camera Company

A high-torque motor built into the camera powers all camera functions in the Contax 137 MD Quartz. It is one of the most fully automatic high-grade cameras on the market. An indicator to insure that the film is tracking through the camera is activated by a permanent magnet that is rotated as the film is advanced.

Nikon F3 1980
Nippon Kogaku K.K., Tokyo
81:3208:1
International Museum of Photography at George
 Eastman House
Gift of Nikon, Inc.

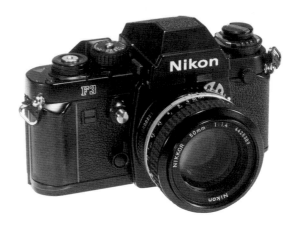

The F3 is the flagship camera of the Nikon organization. The latest model displayed here incorporates a number of refinements including a liquid crystal display of camera functions in the viewfinder. An auxilliary light enables the user to see this information clearly under very low light conditions.

Pentax LX 1980
Asahi Optical Company, Ltd., Tokyo
L84:061:319
Loaned by Japan Camera Inspection Institute,
 Tokyo

The Pentax LX is the premier camera manufactured by the Asahi Optical Company. It incorporates all the latest in optical and electronic refinements, and the body housing has been weatherproofed to seal out dust and moisture. All joined sections of the camera body are fitted with rubber packings.

Chinon Bellami 1980
Chinon Industries, Inc., Suwa
L84:061:320
Loaned by Japan Camera Inspection Institute,
 Tokyo

In the Chinon Bellami, the film advance lever also activates a mechanism that opens and closes the barn door type lens cover and moves the lens assembly into position.

Agfa Selectronic 2 1980
Chinon Industries, Inc., Suwa
L84:061:321
Loaned by Japan Camera Inspection Institute,
 Tokyo

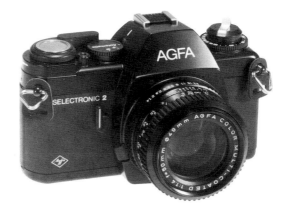

The Selectronic 2 was manufactured by Chinon Industries under contract with Agfa in Germany. It is an automatic-only single-lens reflex with an unusual light-touch shutter release button that has been used on many Agfa products produced both in Germany and Japan.

Zenza Bronica SQ 1980
Bronica Company, Ltd., Tokyo
L84:061:322
Loaned by Japan Camera Inspection Institute,
 Tokyo

The Zenza Bronica SQ is a modern sophisticated medium-format camera with interchangeable backs and lenses. An optional pentaprism with a through-the-lens metering system may be fitted to the camera. This meter couples electronically to the back and registers the correct film speed.

Mamiya ZE 2 Quartz 1980
Mamiya Camera Company, Ltd., Tokyo
L84:061:323
Loaned by Japan Camera Inspection Institute,
 Tokyo

An electronic sensor couples each interchangeable lens to the Mamiya ZE-2 Quartz. It automatically selects the lowest shutter speed possible for hand held operation with each focal length.

Hanimex 35 Micro Flash 1980
Fuji Koeki Corporation, Tokyo
L84:061:324
Loaned by Japan Camera Inspection Institute,
 Tokyo

The Hanimex 35 Micro Flash is an ultra compact 35mm camera with a unique combined front cover and built-in electronic flash unit. When not in use, the cover containing the flash folds, completely protecting all optical surfaces.

Minolta CLE 1980
Minolta Camera Company, Ltd., Osaka
L84:061:325
Loaned by Japan Camera Inspection Institute,
 Tokyo

In 1973, E. Leitz of Wetzlar, Germany, contracted with the Minolta Camera Company to manufacture a compact rangefinder camera capable of using lenses with the Leitz bayonet mount. The CLE is a greatly improved version of this camera with through-the-lens metering. The user has the option of fully automatic or semi-automatic operation.

Minolta Hi-Matic AF-2 1981
Minolta Camera Company, Ltd., Osaka
L84:061:326
Loaned by Japan Camera Inspection Institute,
 Tokyo

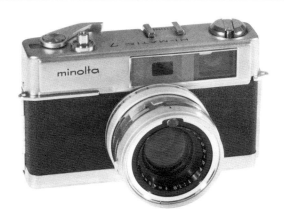

The Minolta Hi-Matic AF-2 is an auto-focusing fixed lens 35mm camera fitted with a built-in electronic flash unit. If the subject being photographed is too distant to be adequately illuminated by the flash unit, an audible beep warns the photographer.

Konica C-35 EF-3 1980
Konishiroku Photo Industry Co., Ltd., Tokyo
L84:061:327
Loaned by Japan Camera Inspection Institute,
 Tokyo

This is a fixed lens compact 35mm camera fitted with an electronic flash. A clever device automatically releases the cassette and locks it into position, facilitating the loading process.

Raynox FC-35 Auto Flash 1981
Hosoi Seisaku-sho Co., Tokyo
L84:061:328
Loaned by Japan Camera Inspection Institute,
 Tokyo

This is an ultra compact 35mm camera with built-in electronic flash. The flash operates automatically if there is insufficient light for an exposure. It is the only camera with a coupled electronic flash with this feature.

日本製カメラの変遷

THE EVOLUTION OF THE JAPANESE CAMERA

Ricoh XR-S 1981
Ricoh Company, Ltd., Tokyo
L84:061:329
Loaned by Japan Camera Inspection Institute,
 Tokyo

The Ricoh XR-S is an automatic 35mm single-lens reflex camera with an unusual feature. A group of solar cells mounted on the top side of the pentaprism housing generates enough energy to recharge partially the batteries that power the electronics in the camera, greatly extending their useful life.

Makinon MX 1981
Makina Optical Company, Ltd., Tokyo
L84:061:330
Loaned by Japan Camera Inspection Institute,
 Tokyo

The Makinon MX is the only interchangeable lens 35mm single-lens reflex camera with a built-in electronic flash system. The flash is coupled to the automatic exposure control system.

Canon 35 AF ML 1981
Canon, Inc., Tokyo
L84:061:331
Loaned by Japan Camera Inspection Institute,
 Tokyo

The Canon Auto Focusing 35mm compact camera is fitted with the fastest lens available (f/1.9) on a camera of this type. It is the first camera to combine auto film advance with automatic focusing. One frame per second can be exposed, and the auto focusing system will make instant corrections.

Mamiya ZE-X 1981
Mamiya Camera Company, Ltd., Tokyo
L84:061:332
Loaned by Japan Camera Inspection Institute,
 Tokyo

The Mamiya ZE-X features a particularly sophisticated automatic exposure control system for aperture or shutter preferred operation. A "crossover" network will automatically override either the shutter or the aperture selected if this choice will result in a speed too slow for hand held operation.

Fujica Auto 7 Date 1981
Fuji Photo Film Co. Ltd., Tokyo
L84:061:333
Loaned by Japan Camera Inspection Institute,
 Tokyo

The Fujica Auto 7 Date is one of the most completely automated cameras ever made. Seven automatic systems are built into the camera, including an electro-optical device that will record the day, month, and year on the film.

Chinon Infrafocus AF 1981
Chinon Industries, Inc., Suwa
L84:061:334
Loaned by Japan Camera Inspection Institute,
 Tokyo

The infrared autofocusing system in the Chinon Infrafocus AF is significantly more sophisticated than that found on many models. It focuses continuously from three feet to infinity.

Fuji Instant Camera Model F10 1981
Fuji Photo Film Co., Ltd., Tokyo
L84:061:335
Loaned by Japan Camera Inspection Institute,
 Tokyo

This is the first instant-image camera made in Japan. The Fuji F10 and the deluxe model also exhibited use a cassette and film type nearly identical to that developed and marketed by the Eastman Kodak Company. The films are, in fact, interchangeable.

Fuji Instant Camera Model F50-S 1981
Fuji Photo Film Co., Ltd., Tokyo
L84:061:336
Loaned by Japan Camera Inspection Institute,
 Tokyo

The F50-S is a deluxe folding version of the Fuji Instant Camera that utilizes the film system devised by the Eastman Kodak Company.

Pentax ME-F 1981
Asahi Optical Company, Ltd., Tokyo
L84:061:337
Loaned by Japan Camera Inspection Institute,
 Tokyo

The Pentax ME-F is the world's first 35mm single-lens reflex camera equipped with an automatic focusing system. The automatic focusing sensors activate a servo motor powered by four AAA batteries housed in the unit.

Nikon FM-2 1981
Nippon Kogaku K.K., Tokyo
L84:061:338
Loaned by Japan Camera Inspection Institute,
 Tokyo

The Nikon FM-2 is the first modern camera to be manufactured with a shutter capable of exposures as short as 1/4000th of a second. An electronic flash will synchronize with the FM-2 at 1/250th of a second, double the normal speed.

Telepac TS-35 1982
Yashio & Company, Ltd., Saitama
L84:061:339
Loaned by Japan Camera Inspection Institute,
 Tokyo

The Telepac TS-35 is an interesting combination of a pair of prism binoculars and a 35mm single-lens reflex camera fitted with a permanently mounted telephoto lens. The field covered by the 9 x 30 binoculars is approximately the same as that of the 300mm telephoto lens. Exposure control is automatic.

Contax Preview 1982
Yashica Company, Ltd., Suwa
L84:061:340
Loaned by Japan Camera Inspection Institute,
 Tokyo

The Contax Preview is basically a special instrument for previewing exposures quickly. A Polaroid Land Instant Film back is fitted to a special housing which accepts Contax/Yashica optics. Standard 24 x 36 mm exposures are made on 3 ¼ x 4 ¼ Polaroid Film Packs.

Mamiya RZ 67 1982
Mamiya Camera Company, Ltd., Tokyo
L84:061:341
Loaned by Japan Camera Inspection Institute,
 Tokyo

The RZ 67 is one of the most modern medium-format cameras available today. The shutter is electronically controlled and coupled to the interchangeable lenses by a series of contacts. A prism finder is available as an option for semi-automatic exposure control.

日本製カメラの変遷

THE
EVOLUTION
OF THE
JAPANESE
CAMERA

Zenza Bronica SQ-AM 1982
Bronica Company, Ltd., Tokyo
L84:061:342
Loaned by Japan Camera Inspection Institute,
 Tokyo

The Zenza Bronica SQ-AM is the first medium for-
mat 120 camera of Japanese manufacture with an
integral motor drive. In the continuous exposure
mode it is possible to expose slightly more than
one frame per second. Exposure control is auto-
matic.

Chinon CE-5 AF 1982
Chinon Industries, Inc., Suwa
L84:061:343
Loaned by Japan Camera Inspection Institute,
 Tokyo

The 35 mm single-lens reflex Chinon CE-5 Auto
Focusing camera uses an infrared sensing system
coupled to a zoom lens. The electronics of the
auto-focus system are coupled to the camera body
and activated by touching the exposure release
button.

Minolta AF-C Camera 1982
Minolta Camera Company, Ltd., Osaka
L84:061:344
Loaned by Japan Camera Inspection Institute,
 Tokyo

The Minolta AF-C is an extremely compact auto-
focusing camera of simplified design. Only a por-
tion of the lens moves to vary the focus.

Fujica DL-20 1982
Fuji Photo Film Co., Ltd., Tokyo
L84:061:345
Loaned by Japan Camera Inspection Institute,
 Tokyo

The Fujica DL-20 is an inexpensive 35mm auto-
matic camera with semi-automatic loading. By
rotating a ring on the front of the camera the pho-
tographer exposes the lens and the viewfinder.
Closing the camera resets the zone-focusing dial to
the hyperfocal distance.

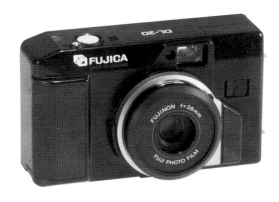

Fujica DL-100 1982
Fuji Photo Film Co., Ltd., Tokyo
L84:061:346
Loaned by Japan Camera Inspection Institute,
 Tokyo

The somewhat cumbersome process of loading
35mm cameras has discouraged many amateurs.
The Fujica DL-100 (the DL stands for Drop Load-
ing) is fitted with a semi-automatic loading system
that greatly simplifies the process. The camera is
fitted with auto-focus, automatic exposure control
and a built-in flash. A motor automatically
advances the film after each exposure and rewinds
the finished roll.

Olympus OM-30 Camera 1982
Olympus Optical Company, Ltd., Tokyo
L84:061:347
Loaned by Japan Camera Inspection Institute,
 Tokyo

An upgraded version of the Olympus OM-10, the OM-30 features an electronic focusing aid. The automatic focusing system developed by the Honeywell Corp. in the United States is built into the body of the camera. In addition to the usual optical focusing method, the viewfinder contains LED's. When the green LED lights up, the camera is in focus.

Nimslo-3D Camera 1982
Manufactured under license by the Sunpak Corp.,
 Tokyo
83:0694:4
International Museum of Photography at George
 Eastman House
Gift of Berkey Marketing Companies

The Nimslo 3D system was designed by an American firm and originally manufactured in the United Kingdom. Early in 1982, the Sunpack Corporation entered into an agreement with the American Nimslo organization to re-engineer the camera to reduce costs and improve quality.

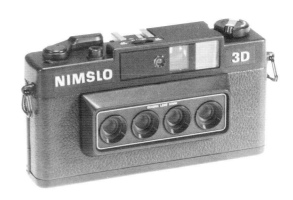

Osram Flash Disc Autowinder Camera 1982
Fuji Koeki Corporation, Tokyo
L84:061:348
Loaned by Japan Camera Inspection Institute,
 Tokyo

The Osram Disc Camera was the first manufactured in Japan under license to use the new Disc film format introduced by the Eastman Kodak Company in 1981. It was manufactured under contract for Osram, a West German firm.

Fuji Instant Camera Model F-55V 1982
Fuji Photo Film Co., Ltd., Tokyo
L84:061:349
Loaned by Japan Camera Inspection Institute,
 Tokyo

The Model F-55V Fuji Instant Camera (the V stands for Voice) is equipped with a voice synthesizer that tells the photographer to eject the darkslide, adjust focus, use flash, and change film. The photographer is also serenaded with two simple melodies. Like the other Fuji Instant Cameras in the exhibition, it uses the film system devised by the Eastman Kodak Company. It is the first camera ever manufactured to be fitted with a voice command system.

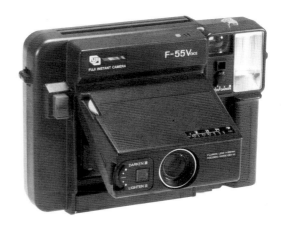

日本製カメラの変遷

**THE
EVOLUTION
OF THE
JAPANESE
CAMERA**

Canon T50 1982
Canon, Inc., Tokyo
L84:061:350
Loaned by Japan Camera Inspection Institute,
 Tokyo

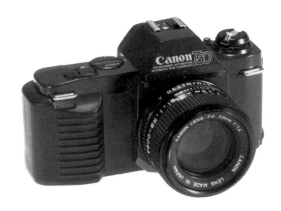

The Canon T50 is a completely automated 35mm
single-lens reflex made on a highly automated
assembly line. A remarkable number of camera
parts including the body and the shutter are made
from specialized plastics. The result is a high-
performance camera that is both light and rela-
tively inexpensive. The standard lens normally
supplied with the camera is a 35 to 70mm zoom.

Enica SX 1983
Niko Kogyo Co., Tokyo
L84:061:351
Loaned by Japan Camera Inspection Institute,
 Tokyo

Before the Second World War, a firm in Riga, Lat-
via, introduced the Minox, the smallest pocket
camera that had been produced at that time.
Minox cameras are still readily available; the Enica
SX uses standard Minox films, but it is equipped
with a built-in electronic flash, the first camera of
this size and format to be marketed with this
feature.

Vivitar TEC 35 Autofocus 1983
West Electric Co., Osaka
L84:061:352
Loaned by Japan Camera Inspection Institute,
 Tokyo

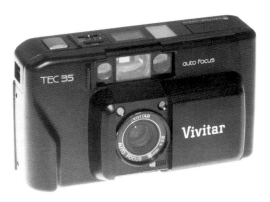

On the Vivitar TEC 35 Autofocus a liquid crystal
display on top of the camera indicates both the
ASA setting and frame number that has been
exposed. It is the first such camera to be equipped
with this feature. The electronic flash unit auto-
matically positions itself if the light level is
too low.

Minolta Disc 7 1983
Minolta Camera Company, Ltd., Osaka
83:1001:1
International Museum of Photography at George
 Eastman House
Gift of Minolta Camera Company

The Minolta Disc 7 is a premium camera designed
to use the Disc film format introduced by the
Eastman Kodak Company in 1981. An unusual fea-
ture is a mirror mounted on the front of the cam-
era. When used in conjunction with the self-timer,
self-portraits can be made.

Goko UF 1983
Sansei Koki Company, Ltd., Kawasaki
L84:061:353
Loaned by Japan Camera Inspection Institute,
 Tokyo

The Goko UF is a very simple 35mm camera with
a built-in electronic flash. It is a fixed focus camera
with an unusual design feature. Activating the
electronic flash automatically moves one of the
lens elements out of position, refocusing the cam-
era to a maximum of ten feet, the distance cov-
ered by the flash.